Paul Harris

MODERN ARTISTS

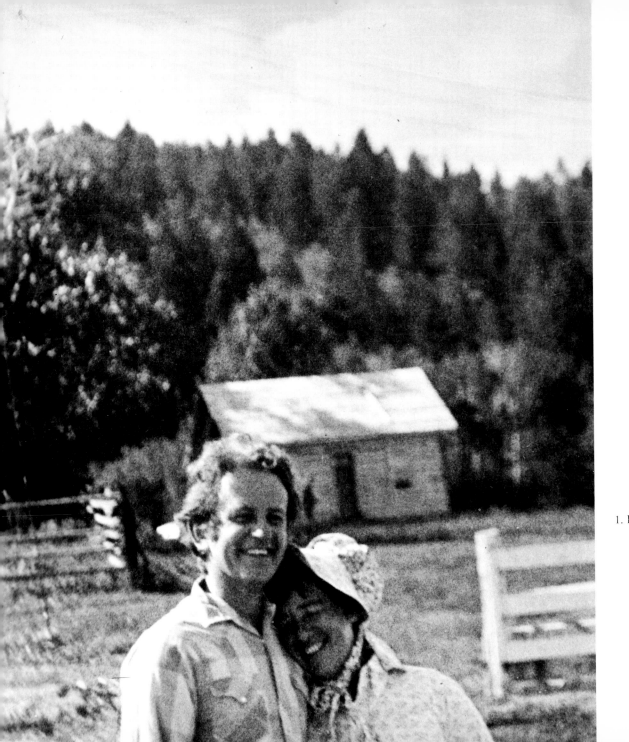

1. Paul and Marguerite Harris

Denis Leon

Paul Harris

HARRY N. ABRAMS, INC., PUBLISHERS, NEW YORK

Acknowledgments

For their time, encouragement, and good judgment, the author and artist thank Frederick Crews, Phyllis and Richard Diebenkorn, Thomas M. Di Franco, Alvin H. Goldstein, Jr., Ann Hardham, Elinor Poindexter, Paul and Dorothy Schmidt, and Edwin Todd.

Joan Leon typed and proofread the entire manuscript. Judy Lien prepared the bibliography. Roger Gass took hundreds of photographs of both old and new pieces. These tasks required long hours and extended enthusiasm.

<div align="right">

Paul Harris
Dennis Leon

</div>

Nai Y. Chang, Vice-President, Design and Production
John L. Hochmann, Executive Editor
Margaret L. Kaplan, Managing Editor
Barbara Lyons, Director, Photo Department, Rights and Reproductions
Bitita Vinklers, Editor
Christy S. Nettles, Designer

Library of Congress Cataloging in Publication Data

Leon, Dennis.
 Paul Harris.

 (Modern artists)
 Bibliography: p.
 1. Harris, Paul, 1925–
N6537.H36L46 709'.2'4 75–1480
ISBN 0–8109–0359–8

Library of Congress Catalogue Card Number: 75–1480
Published by Harry N. Abrams, Incorporated, New York, 1975
Printed and bound in Japan

Contents

List of Plates

*Colorplates are marked with an asterisk**

We are all constantly in the process of locating ourselves, primarily by means of recording the outer limits of our sensibilities. We have to know where the self stops and the outer world begins. Perceiving a figure by Paul Harris involves a similar process—we need to observe where the figure is and what territory it claims for its own. Harris's sculpture shows both the artist's concern for this process and his skill in encouraging the viewer, by many means, to seek either an answer to it or an appreciation of the sculpture's ambiguity.

This process of orientation in art is particularly a twentieth-century phenomenon. It presupposes an existential concept of the individual in which, at any point in time, the person can be described by a number of ongoing relationships. Moreover, he is less the cause of the relationships than he is an integrated part of them. An artist's intelligence, therefore, is often objectively applied primarily to the language of description, and increased importance has been placed on paradox and continuity—two fundamental means that the viewer must recognize in order to establish his relationship to a work of art.

By paradox, I mean a conflict of references, such as a conflict in scale or in space. The viewer recognizes such a paradox but believes in its potential resolution as he undertakes to integrate himself with the work. By continuity, I mean the devices offered by the artist for the viewer to overcome what might otherwise be only baffling paradox. For example, a convincing spatial continuity will permit ambiguous but readily acceptable changes of scale.

The following very brief story by Paul Harris exemplifies this artistic approach.

INCIDENT

In a great white room with a tall door there is an immense bed.

The door opens, and a man of average build enters, followed by a pretty woman who is almost twice his size. To pass through the door, she must bend slightly, but her hair does not brush the ceiling.

The woman looks about the room, sees nothing, and sits down on the end of the bed. With her hand in her blouse she adjusts her bra strap.

The man in the meantime has shut the door and is standing, with his knee on the bed and a hand on her shoulder. As she turns her attention from her strap to him, he throws his arms around her, presses his small mouth against her great one, and pushes her back upon the bed. He seems to desire her passionately and immediately. She is indulgent but not passionate, letting him have his way as a mother might a child.

In his frenzy he finds it hard to unbutton her blouse and to unlatch her bra. Not wanting to have her bra broken, she undoes it herself and sets free her enormous breasts. The man is in a hurry and begins to pull at the placket of her dirndl skirt. Again she aids him, by undoing the fastening and dropping the skirt to the floor.

The man is frenzied now. He is on his feet, ripping off his shirt and trousers. Clad in his undershorts he leaps back upon her and claws at her panties. With one hand she wiggles them down to her ankles and kicks them carelessly off. The man begins to rub his hand over her pubic hair, round and round, up and down, round and round. The woman brings her limbs up onto the bed and, with her knees bent, slowly separates her legs. As the man is wildly massaging the pubic region the vulva breaks into a huge smile. While it grows wider and longer the man snatches at his undershorts and pulls them off.

The eyes of the woman are shut now and there is a smile of peaceful surrender on her lips. The man stands on the bed and puts one hand on each of her knees. Then like a bather testing the temperature of the water, he inserts his toe into the vagina. First one foot and then the other—as if he were entering a kayak. His weight is on her knees but his feet and legs are inside her, pushing toward her stomach. He lets himself down into a seated position. He is tense and careful, thrusting himself forward as one would into a sleeping bag. His shoulders disappear and then his head. The kayak is empty. The vulva closes like a flower.

The woman rouses from her sleep. She rests on her elbows and looks about. She reaches for her bra and puts it on. Then the blouse, the panties, and finally the skirt. Seated on the end of the bed she touches her hair and finds one lock askew. She looks back to where her head rested on the bed. Seeing her hairpin she reaches for it, raises her huge arms, and snaps it into place. Then, with but a little straightening of her clothes, she gets up and, stooping slightly, exits through the door, which she forgets to close.

The reader of this short story, like the viewer of Harris's sculpture, is encouraged to become an involved witness—which means that the resolution of the experience is quite clearly the problem of the reader—although the artist has carefully, through symbol and language, used several relationships both to present his own values and to inform the witness. Basically, we believe the dramatic physical paradoxes (the people's contrasting sizes and the man's disappearance) because we can believe in the continuity of the story's time. How we sense the meaning of the whole experience is determined by how we relate to the specific information. The meaning of the story is about how we relate to it.

SOME BASES FOR CONSISTENCY

Paul Harris has, thus far, explored several different modes and many kinds of materials: figures, masks, and heads made from plaster, paper, and bronze; still lifes, landscapes, and abstractions in plaster and bronze; object-environments of woven and suspended fibers and fabrics; lithographs; and the stuffed sewn women made from cloth for which he is perhaps best known. This apparently restless shifting about is characteristic of many twentieth-century artists. The artist stands in relationship to his work in a role very similar to that of the witness as described above. Harris professes quite sincerely a great admiration for an artist such as Morandi—who daily seemed able to identify his search with a fairly restricted vocabulary of forms and, in so doing, cast himself more in the role of arbiter. In contrast, Harris has chosen himself and his own changing sensibility as a witness to be the constant factors in the changing situations of his forms and materials.

This constancy is revealed, in part, by the artist's continued commitment to the following four basic concerns.

1. Image

With only very few exceptions, all of Harris's work is figurative. I believe that he sees his sculpture as most meaningful to him when image and reality interact in rich symbiosis. He creates images that evoke ritual—either directly, as with some of the masks, or through the sharp, sometimes satirical, sometimes theatrical eye of the sculptor, as with the stuffed sewn women. Furthermore, he tends to serialize his thoughts about a given image so that we eventually understand that, no matter how important the basic image is, it becomes a device for approaching some underlying meaning. For example, the heads in the masks are not always the same head, and the women in the lifesize figures are not always the same women. After the viewer has seen a group of works, however, it becomes possible for him to build some kind of composite image that is fed by a single piece, which, in turn, illuminates that piece and others. The symbiosis of image and reality becomes a symbiosis of image and image.

2. Material

The materials with which Harris makes his sculpture are almost always used directly—both in technique, since relatively few pieces are cast, and in concept. I believe that during the artist's two-year visit to Chile (1961–62) his work with fabric and fibers enabled him to clarify his feeling for material. (Harris was, however, working directly with cloth in the form of braided rugs as early as 1950 in New Mexico.) Since visiting Chile, he has seldom missed an opportunity to encourage the viewer to a direct response to the "stuff" of which the work is made. He appears essentially to use this directness of visual response most frequently as a foil to the image. The material frequently functions critically within the paradox and continuity referred to earlier.

3. Position

Harris is interested in locating a whole form in space and, in turn, relating its parts spatially to each other. He

is, in this sense, a traditional sculptor. He is committed to a belief in the possible plausible meanings to be derived from a study of fixed spatial positions in relationship to one another. The forms in the cloth figures are, therefore, held to a rigid surface and precise spatial location. Although materials such as cloth and stuffing could lend themselves to "soft" sculpture (by allowing gravity to designate their spatial positions, in which case gravity would act as a basis for continuity), Harris's sculpture is "hard." The materials function paradoxically and, by and large, the traditional commitment to position, therefore, provides the continuity. That is why the forms in the cloth figures are held to a rigid surface and precise spatial location. The personal sensibility in the pieces is a rich combination of the artist's human compassion and his intellectual appreciation of, and commitment to, composition through the physical positioning of parts.

4. Attitude

With the exception of some private pieces that Harris has not exhibited, his normal working procedure is to allow the grouping and sequencing of forms to spread outward from a real but never designated point. The boundaries of the piece are extended until the maximum expansion, without dispersal, is achieved (a traditional concern of a modeler). This rather formal approach parallels a more metaphysical attitude on the part of the sculptor, on which he bases his judgment about the quality of the piece. It is difficult to write about what a sculptor means by quality or the phrase "it works," but

I believe that Harris thinks of that maximum expansion as an indicator of the energy potential and of the non-designated point as the secret energy source, which, according to the piece, can range from magic to enigma, from the macabre to the ingenuous, and from tragedy to comedy. What is most important, however, is that Harris's attitude to quality—like his attitudes to position, material, and image—is clear and consistent throughout his work.

GROUPINGS

An overview of Paul Harris's work since 1952 reveals six basic groups. In some instances the sequence from piece to piece occurred chronologically with no interruption, but in others an idea has been reinvestigated, with changes, at a much later date. The groups are: (1) figure compositions dominated by a standing, waiting man; (2) masks and heads; (3) still lifes and landscapes; (4) woven string pieces; (5) lithographs; (6) stuffed sewn women.

1. Figure Compositions Dominated by a Standing, Waiting Man

This group of pieces constitutes the sculptor's earliest work. Frequently executed initially in plaster, these sculptures have a quality of stylization and self-consciousness like that in Lehmbruck's work. The image of the standing man (which I am sure had a very personal meaning for Harris) is of particular interest, and is an idea that the sculptor has investigated several times.

The silhouettes of these pieces function as the primary

visual or formal reference, since the viewer is encouraged to find the form by working from the outside in. As a result, the air surrounding the sculptures tends to press aggressively against the surface, and the forms themselves have to resist. Furthermore, there is a tendency toward a continuous silhouette with very little overlapping; thus the procedure of discovering a real but nondesignated point, as described above, is reversed—the boundaries appear to generate a point rather than a point generating the boundaries through expansion.

I believe that Harris uses this reversed procedure from time to time as a foil or as an obstacle to his preferred and "normal" process. Many artists build obstacles for themselves that permit the accumulation of frustration or of energy, which functions like a dam for a hydroelectric generator. At intervals through the years, sometimes in pieces that are either not completed or have never been shown, Harris has repeated this process.

2. Masks and Heads

For Harris, the motif of masks or heads has occurred and reoccurred over many years. This motif is, I suspect, one of his most direct means of testing and qualifying the kinds of content that interest him. The head has traditionally been used, because of its ability to be holistic yet not dismembered, somewhat in the same way as a poem or short story can be contrasted to a novel, which is the full-length figure. The analogy can be pushed even further in the use of a mask.

Clearly, the artist's intent in these works is not naturalism—indeed, the very concept of mask is normally contrary to the idea. Instead, among the best of the pieces, the dominant qualities range from magic and mystery, through ritual, to humor and death. The notion of ritual is inherent in a mask (which perhaps, in part, explains Harris's interest), since it provides a context within which we try to understand how the mask might be used. We are probably obliged to seek a context whenever we encounter any sculpture of a head that is clearly not naturalistic, and therefore the option of ritual is frequently with us. Harris uses it repeatedly and innovatively.

Unlike many other sculptors, Harris seldom offers an art-historical concept or style (for example, Cubism) as the context within which the piece is to function. This is why, when looking at the masks and heads, we turn so quickly to thoughts either of magic and mystery or of expression and the artist's personal gesture. His use of the image is frequently tempered by humor. Harris finds meaning in a quotation from W. H. Auden: "Only through comedy can one be serious."

Although it is difficult to differentiate clearly among humor, playfulness, and comedy, all of them are at work in *Child's Face* (plate 8), dated 1953. And certainly, all of them function to generate an image that ultimately speaks of seriousness.

3. Still Lifes and Landscapes

Paul Harris has, from time to time, investigated the still life and the landscape both in two and three dimensions—although thus far landscape has certainly been most fully treated in his lithographs. The still lifes concentrate on the identification and depiction of an object;

this approach in the still lifes seems to serve as a foil to Harris's figures. Yet, in both kinds of works he has a common purpose—using a paradoxical image within a continuity of a convincing time or space sense—in exactly the same manner as in the short story quoted earlier.

The still lifes, with little or no distortion either in configuration or scale, function within our normal physical world and time sense. The selection of images, their juxtaposition, and their translation into bronze, however, produce a polarity between the real and the depicted, between the natural and the cultural.

Within this polarity we develop a sense of alternatives without going so far as actually making a choice. Therefore, since we suspend a decision-making activity (a "willing suspension of disbelief"), we experience a sense of stillness and quietness. It is this experience that we use to qualify the continuity.

4. Woven String Pieces

This rather extraordinary group of pieces was executed in 1960–62. These works are of particular interest in Harris's development for several reasons. First, they tend to be larger in size than usual, since most of his pieces are life-size; second, they are predominantly nonfigurative; and third, they actually are soft—that is, gravity does function to establish the form (Harris's later figures, in contrast, although made from cloth, are well within the tradition of forms that are physically rigid). Although he has always had a sensitivity for color, Harris perhaps really clarified best in these pieces how he wanted color to function in his work. The color is integrated into the

form and is a part of our immediate perception of the material.

Most of the sculptures in this group are quite distinct from the rest of Harris's work in that our encounter with them takes place totally within real physical space—in fact, some of them function directly to modify the space around them. Harris refers to them as "collapsible pieces" —a description that recognizes their fundamentally physical nature.

In part, I regard them as being a rich source of ideas that Harris has applied later. These ideas include the use of material to exploit its physical properties; the interplay between the work of art and real space; and a direct and connotative use of color.

5. Lithographs

The notion of comedy as the avenue to seriousness in Harris's work is most readily visible in his lithographs. The sense of comedy here is usually built upon a series of overlapping references; each one is directional but is itself incomplete. To clarify this idea I will describe the lithograph *Outdoors* (plate 45).

The print covers the entire piece of paper—there are no margins. We could thus assume the extensibility of the forms but, as yet, we do not understand the limit placed on them by the edge of the paper. The paper thus begins to suggest that it, itself, is the primary reality—a concept encouraged by the narrow white band running across its middle. But the band does more than reinforce the sense of the actuality of the paper; it divides it into two areas, one above and the other below. Furthermore, it produces

a spatial illusion of depth that begins to contradict our initial observations about the paper. The white band is also simply the surface on which there is no black line grid printed. It is either there because it is real, or it is the absence of something else that may be real—the grid.

Although I could continue, the point has been made— the entire visual experience of the lithograph is made up of a series of road signs pointing in different directions. We move a few steps in each direction and, in effect, find ourselves doing a little comic dance before we settle down to realize that the road signs themselves are the substance of the work. Yet the substance (that which is serious) cannot be probed without the dance (that which is comic). The comedy is enhanced when we discover not only the formalisms I have outlined, but the idea that the lithograph is a view of and through a window. It is a view Harris lived with while in Los Angeles, at the Tamarind Lithography Workshop.

6. Stuffed Sewn Women

I have thus far used the stuffed sewn women to make certain points of contrast—as though these works were some kind of touchstone. I am sure this is so because, to date, they embody most comprehensively Paul Harris's thoughts and feelings about sculpture. Later I will describe one piece in detail, but first I want to identify some characteristics of the group.

They all have in common the use of cloth that is stuffed and stitched together. The technique encourages (actually necessitates) the perception of the fabricating process and therefore the perception of the specific material.

A quality of realism is created by the lifesize scale of the figures—a quality most frequently augmented by the incorporation into the sculpture of a piece of furniture that immediately relates the figure to the floor that we share with the work. This realism is, of course, instantly established in the work by the images Harris uses—most frequently the image of a woman in the middle of a gesture motivated by circumstances occurring before we meet her. (Recall the short story quoted earlier in which the circumstances of the two people's relationship were set before the story starts.)

All of the pieces in this group involve the integrated use of color. The color is used (and used expertly) to qualify the circumstances in which we find the lady. Lacking other kinds of specific information, such as all the features of the face, we use the color and patterns as resources to probe such questions as: "Is she happy?" "Is she wealthy?" "Who is she?" The color functions connotatively with respect to the image and it also functions to describe and ornament the sculpture as an object.

It carries out the latter function by presupposing the relative closeness of the observer to the work, for in almost all of Harris's work there is some aspect of intimacy, since almost all of it is created for an interior space.

It seems apparent that Harris, in terms of the image of the woman, is not pursuing a vision of a mythical archetype, since the women all appear to be in a condition of transition. Instead they reveal an inquiry about a personal vision of woman as she relates to or perhaps symbolizes the artist's present culture. The woman is offered as a synchronic metaphor against the diachronic segre-

gated object which is the sculpture. In one sense, the object itself is atemporal and segregated from its environment; in another sense, particularly in terms of the woman-image, our experience is in real time and the image is integrated with our environment. The sculpture itself is offered as paradox and the woman is offered as continuity.

THE CONVALESCENT

The Convalescent is a sculpture made of cloth, stuffings, and a wicker chaise longue completed by Harris in 1965 (plate 38). It is reasonably typical of its group. As such, it creates a delicate balance between the two poles of its immediate objective properties and its connotations. The viewer, however, need not identify these poles before responding to the work. Harris himself, in discussing sculpture, tends to pursue an intuitive kind of response in terms of feelings: "What is its mystery?" "With what part of my body do I feel this sculpture?"

To me, the image is the dominant actor in the play, and yet it informs us less about the play than the play informs us about it. Therefore, I will examine the context of the image first.

As stated, the sculpture exists as an object of certain physical characteristics. It is a man-made object understood within the concept of sculpture, and as such it speaks of a process of assembly. Because we can see how larger forms have been made by the joining of smaller ones, our visual response constantly oscillates between the perception of parts and the perception of lesser or greater wholes. The oscillation releases energy, which we apply back to the piece in terms of interpretation. The combination of parts of the chair can be interpreted in terms of time past—of how it became the way it is. The combination of parts of the body (notice particularly the feet and the chest) speak not only of time past, but of time future; the toes may wiggle, or the chest may rise and fall.

The object itself appears to be made up of two components (for which, incidentally, there are two distinct color cues): the chaise longue and the figure. The farther away any part of either one is from the other, the more independent it is. The legs on the chair, the rim around the back, and the ledge in front all belong exclusively to it, but the woman's toes, the fingers on her left hand, her chin, and her mouth belong exclusively to the figure. Conversely, the closer the two objects, the more interdependent they are—so much so that in some instances the same space is shared by both objects: for example, the areas described by the figure's arms, head, and heels. The top plane of one object is largely shared by the bottom plane of the other.

The sculpture, as a geometric object, is controlled by the geometry of the chaise longue—which is basically a rectangular solid with six sides. The top side, however, because of its complexity and the presence of the figure, is the most informative and therefore the most important side. Indeed, it functions rather like a horizontal doorway, or like the lid of a box. The predominance of the top is further intensified since the chair acts both pictorially as a frame for the figure and tactually as a support for it.

The cloths that form the surfaces are dominated by the blue gown and the golden chair. Both have a sheen and a

richness of light reflection. Although fundamentally compatible, they act in complementary opposition to each other. This process is repeated, but inverted, with the other two materials—the cloth for the skin and the cloth for the pillow. They resemble each other in their absorption of light, but oppose each other in color. In one case there is the shiny blue figure versus the shiny gold chair, and on another level the dull gold figure versus the dull blue chair. As the eye crosses from figure to chair and back again, it rides on simultaneous and paradoxical paths of blueness, goldness, shininess, and dullness in changing combinations.

It is perhaps time for the dominant actor—the figure—to come on stage. The woman is lying on the chaise longue, with all but the slightest portion of her weight borne by it. Her position on it of course reflects the title of the sculpture. The sculpture is, moreover, evocative of an Etruscan sarcophagus, both in imagery and in the function of the top as the lid of a box. The woman's bodily position indicates surrender and vulnerability. Furthermore, her vulnerability suggests not only convalescence but also eroticism. The cloth and the design of her gown, which reveals her form and emphasizes the bare feet and partially exposed breasts, generate the sexual or erotic associations possible in convalescence. This connotation is also created by the woman's left hand and her mouth. Her hand, coupled with the angle of the head, relates her to the space in which the viewer stands, and as a result he feels that he is being vaguely and somewhat elegantly addressed by the woman, who appears to be reacting to his presence. The mouth, of course, is the most frankly

used symbol in the sculpture to qualify the image: like the breasts (and perhaps the soles of the feet), it is quite sexual.

The crisscross inversions I have observed about the cloth and color are paralleled in the image by the crisscross between eroticism and convalescence. Paradox and continuity are used to inform us how an individual simultaneously generates relationships and is defined by them. *The Convalescent* shapes our response, and we in turn shape the image.

Consider, in conclusion, another brief story by Paul Harris.

EVELYN

Our father had gone with Miss Hamilton before the War, before he had married, and before she had become paralyzed from the waist down. After the death of our mother, our father used to take us somewhere every Sunday afternoon. One of our regular stops was Miss Hamilton's, where she would have been set out upon the porch before we arrived.

Our father would sit on the porch and talk with Miss Hamilton and with Colonel and Mrs. Hamilton, her parents. For my sister and me the visit offered no diversion except for a long close look at Miss Hamilton herself. We thought her hair looked like pages of handwriting practice—a line of capital C's in one direction and then in the other, tight to her head. And it was always remarkable for us that everything in which Miss Hamilton was dressed or wrapped or set was pink. Pink linen and silk and taffeta.

There were many Sunday afternoons between my fa-

ther's War and my own. We spent a large share of them on Miss Hamilton's porch. When I returned home from my War our father proposed that I should pay a visit to Miss Hamilton who, he said, was "just about the same."

Colonel and Mrs. Hamilton were no longer sitting on the porch. A woman in nurse shoes took me to Miss Hamilton. Oh, father, yes, how much the same—pretty porcelain face, darkened cavities, embroidered hair, and the pink, let me tell you, salmon and rose. Pink-pink, blue-pink, orange-pink, purple-pink, black-pink. She invited me to put my chair near her bed.

"Dear Paul!" She put her small hand on mine and looked into my eyes. "Dear Paul, dear Paul . . . you really, really don't look Jewish! Hand me, dear, a handkerchief." The handkerchief drawer . . . how big was the handkerchief drawer? I suppose it was the size of the usual drawer or the size of a steamer trunk, or of a train depot for handkerchiefs, pressed, pink, starched, stacked, and ready to go. I gave Miss Hamilton the one on top but she gave it back.

"What a garish one to choose for me!"

I had, I felt, no right to keep her; visits are wearing. "Miss Hamilton, I must go." Her small hand was strong. "Ask your father if he remembers an Evelyn Hamilton." When I bent to kiss Miss Hamilton good-bye on the forehead, she tightened down on my hand. "Put that kiss where it's supposed to be."

Supposed to be . . . where . . . where should it be? Red blushed kiss lost in a depot, and on steamships dropped in drawers under white shoes through rug fields and off the old porch. Father, can you remember the Hamilton girl?

Plates

2. *Tea.* 1954. Ink drawing, 8 x 10″

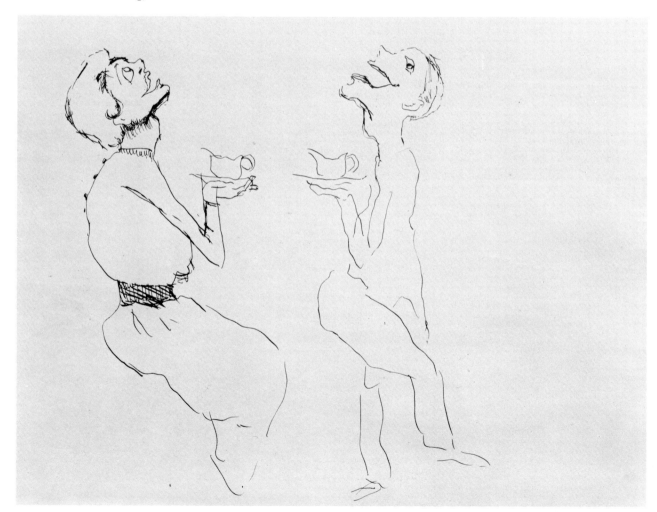

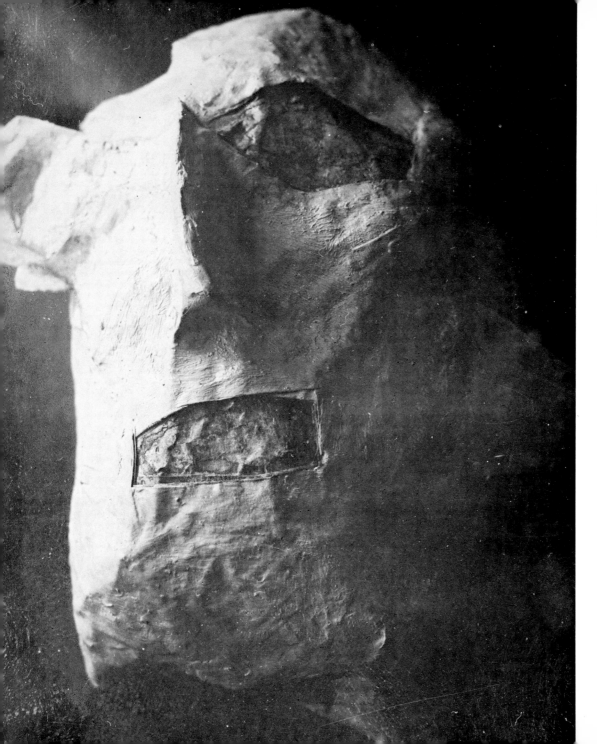

3.
Anonymous. 1952.
Painted papier-mâché,
11 x 9 x 5″

4.
Woman. 1953.
Pencil drawing, 10 x 8″

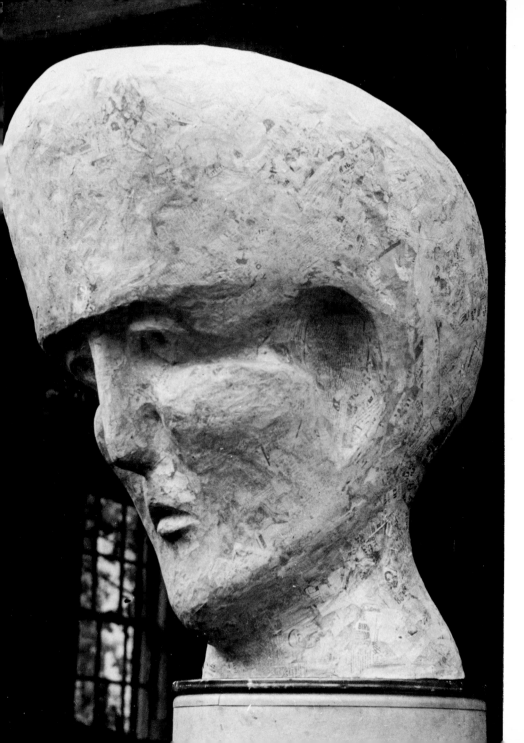

5.
Head. 1954.
Papier-mâché, 60 x 25 x 41″

6.
Nude. 1953.
Ink drawing, 10 x 8″

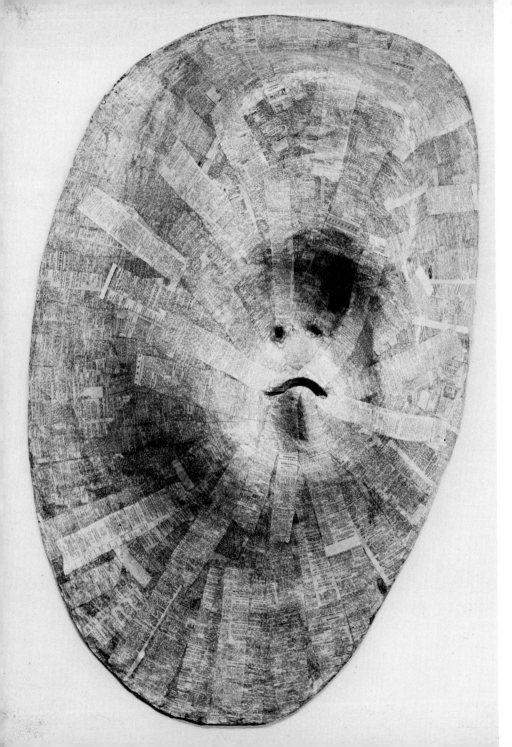

7.
Garden Hat. 1956.
Papier-mâché, 48 x 25 x 12″.
Collection Robert Graham, Stamford

8.
Child's Face. 1953.
Papier-mâché, glass eyes,
11 x 10 x 7″

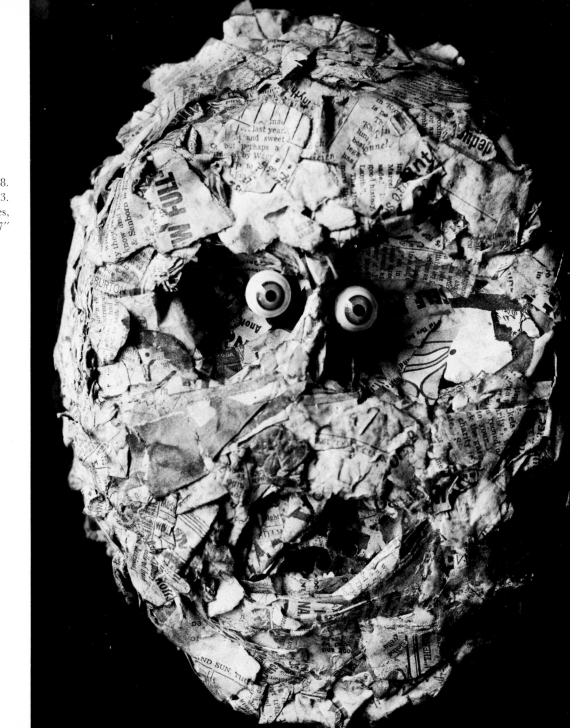

9.
Portrait of a Thin Man. 1969.
Painted wood, papier-mâché nose,
22 x 17 x 5″

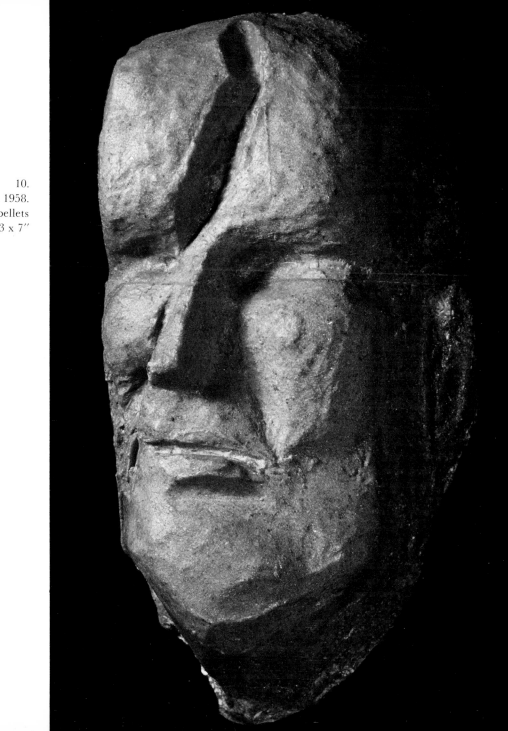

10.
Portrait of a Father. 1958.
Resin with mica pellets
and mica chips, 25 x 13 x 7″

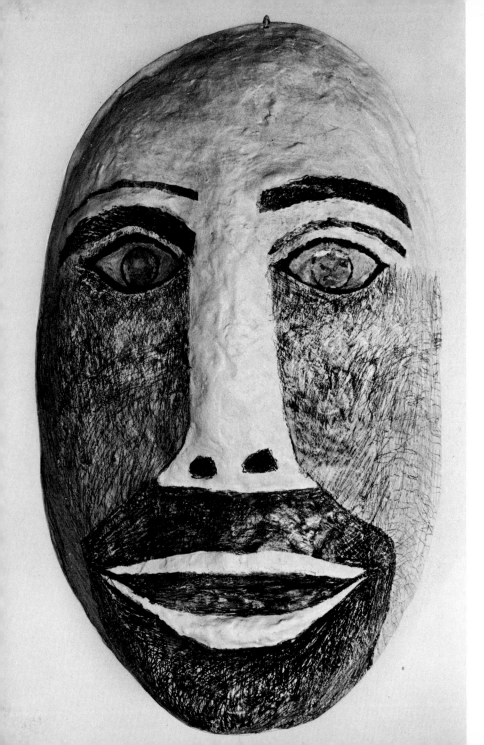

11.
Bearded Man. 1954, 1969.
Painted papier-mâché, 14 x 9 x 6″

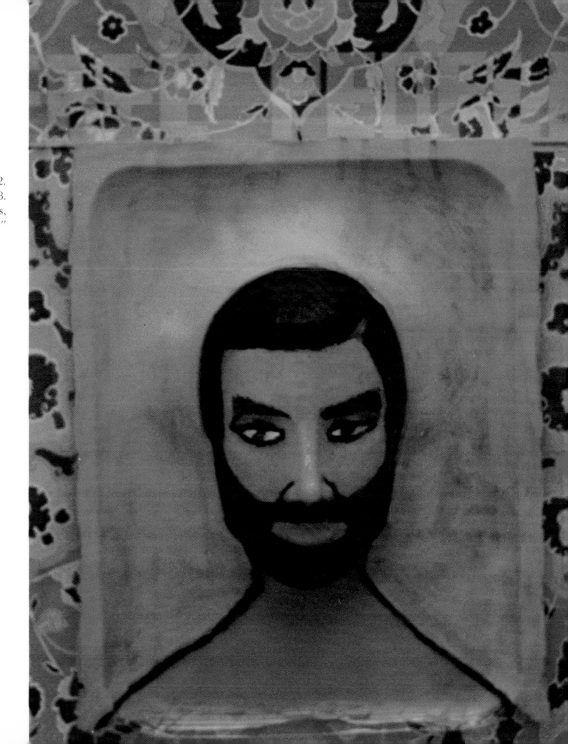

12.
Man in a Yellow Room. 1968.
Vacuum-formed plexiglass,
painted, 21 x 16 x 7″

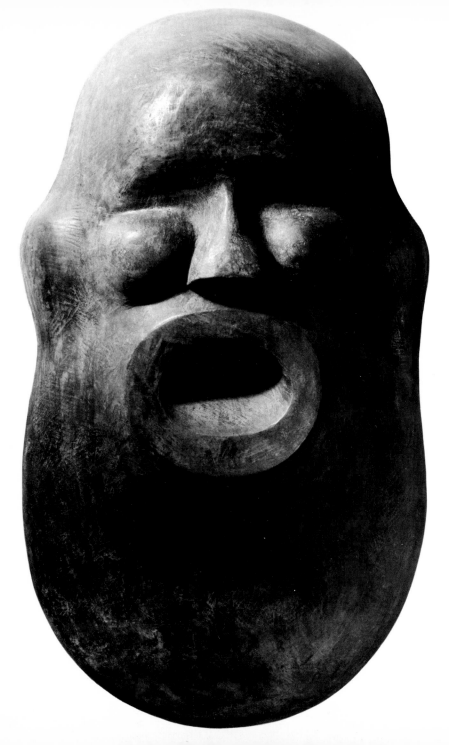

13.
Man Wailing II. 1972.
Bronze, 30 x 18 x 7″.
Collection Paul and Dorothy Schmidt,
Bolinas, Calif.

14.
Agent. 1968.
Vacuum-formed plexiglass,
painted, 21 x 16 x 7″

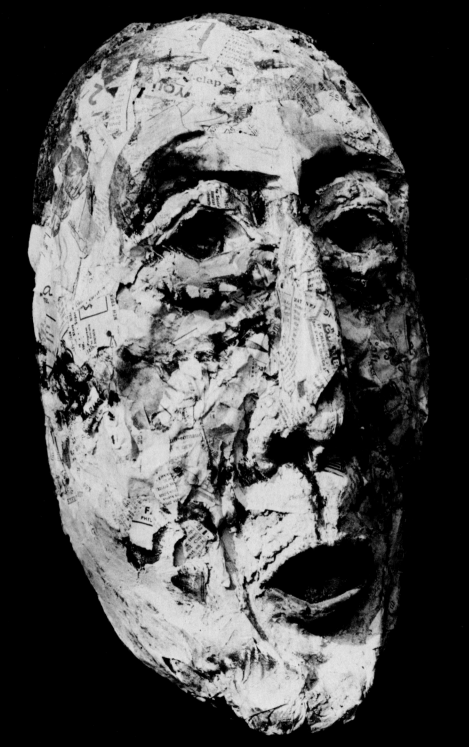

15.
British Playwright and Dramatist. 1953.
Painted papier-mâché,
rope, and putty, 16 x 10 x 8″

16.
Mary Jane As I Knew Her. 1958.
Painted papier-mâché,
29 x 14 x 12″.
Collection Elinor Poindexter, New York

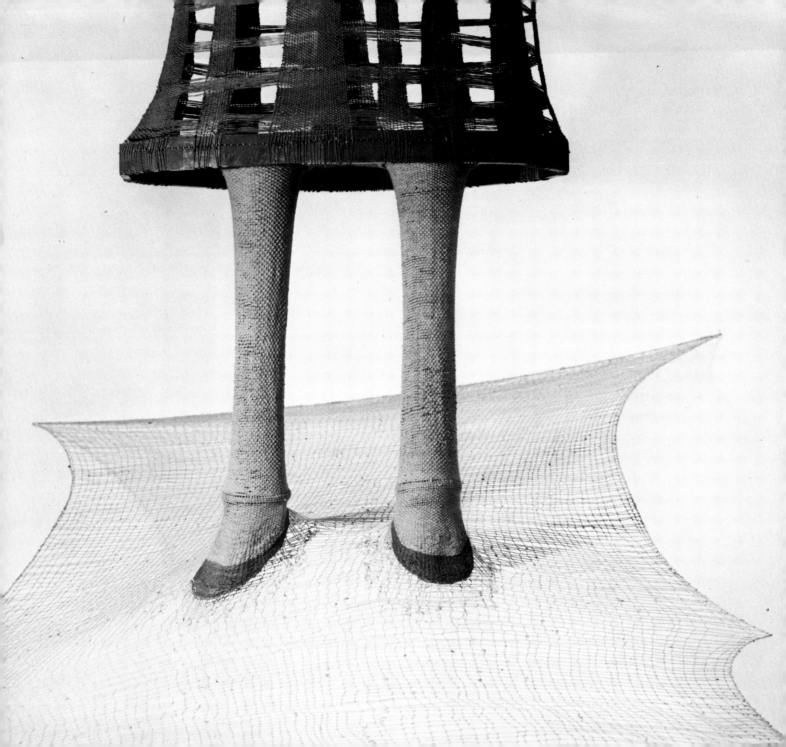

17.
On the Grass a Lass. 1962.
Woven string on a
wood frame and
a metal frame, 6'8" x 10' x 11'8".
Collection Samuel and
Clara Lebovitz,
Irvington, Va.

18.
On the Grass a Lass

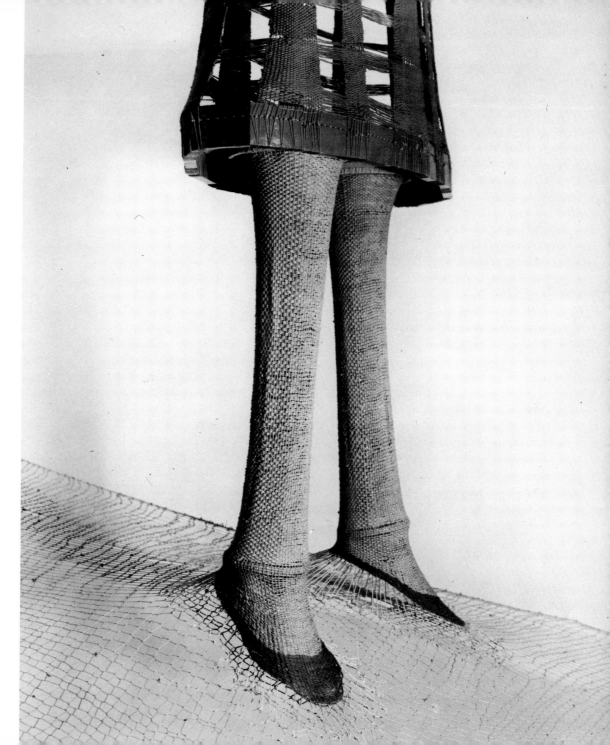

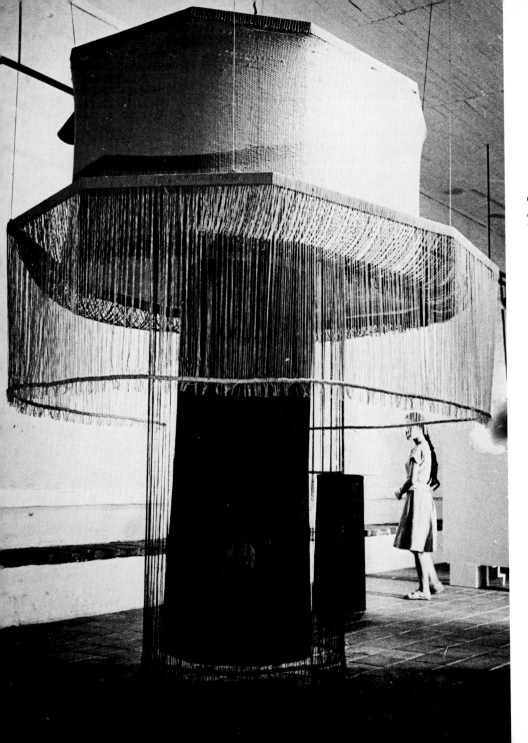

19.
*Collapsible: Monument to
an Unknown Father.* 1961.
Woven string on
wood frames, 9′ x 6′

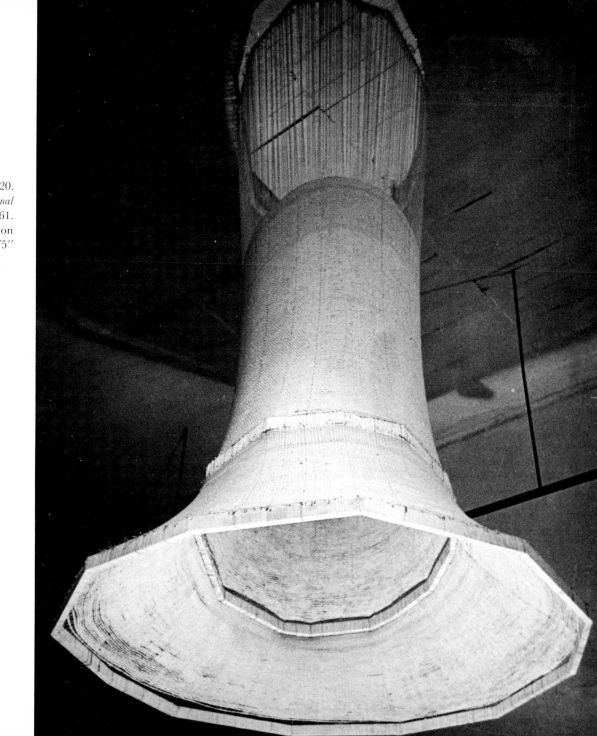

20.
Collapsible: National Monument. 1961.
Woven string on wood frames, 9′ x 5′5″

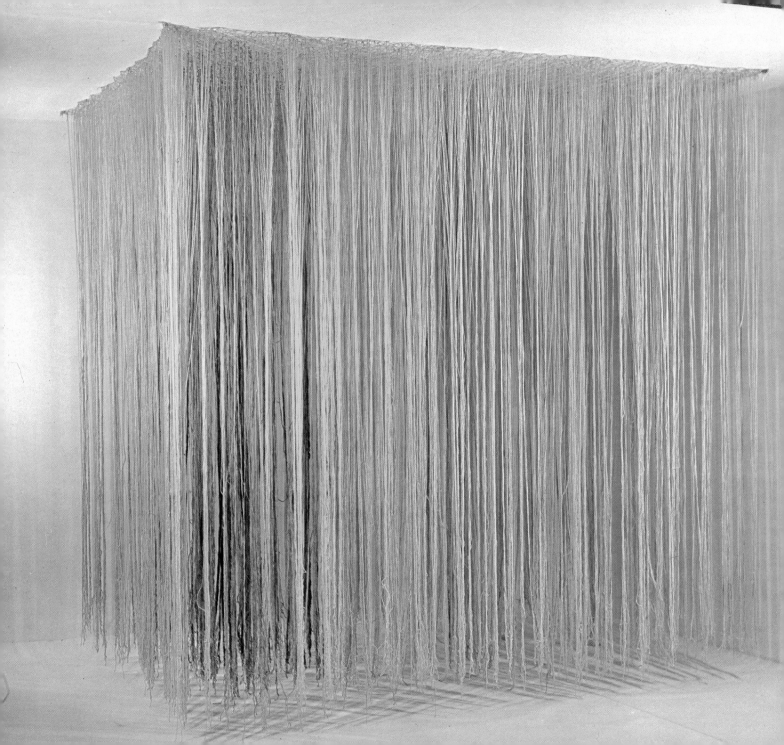

21.
Collapsible:
Rapunzel. 1962.
Tied string,
9'2" x 8' x 8'4"

22.
Collapsible: Rapunzel

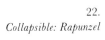

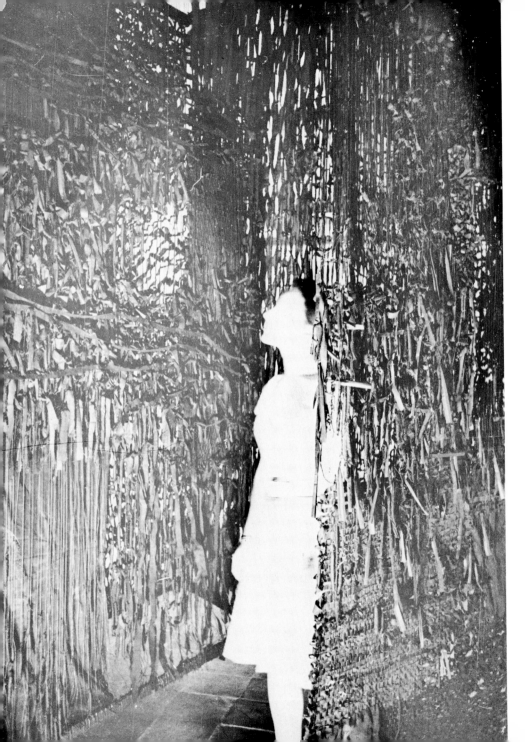

23.
Collapsible: Cathedral. 1961.
Woven string with
wood pieces, 8′ x 8′4″ x 7′

24.
The Visitor. 1969.
Stuffed cloth hands
on assisted chair, 34 x 23 x 24″

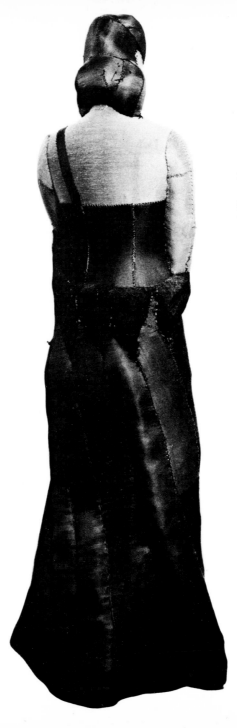

25, 26.
Woman Coming In. 1966.
Stuffed cloth on metal frame,
72 x 27 x 14″

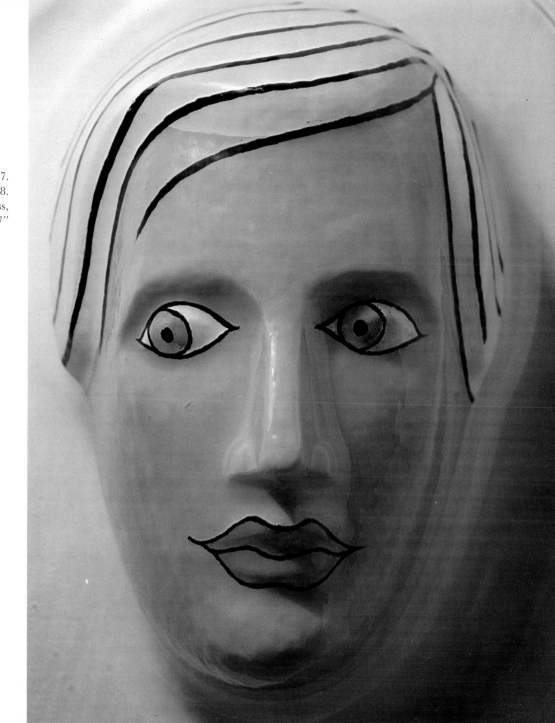

27.
White Man. 1968.
Vacuum-formed plexiglass,
painted, 21 x 16 x 7″

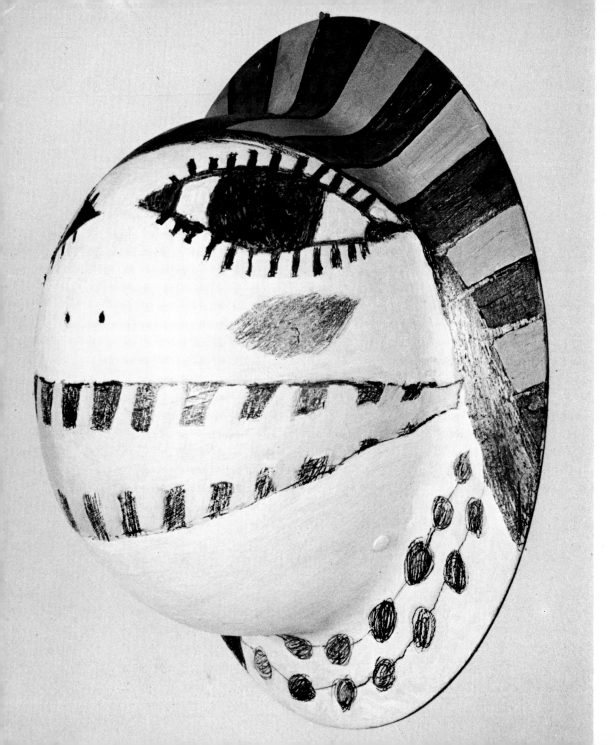

28.
Woman in Pink Hat. 1969.
Painted helmet,
10 x 13 x 9″

29.
Woman in a Pink Gown. 1964.
Stuffed cloth on
wood chair frame,
44 x 25 x 32″

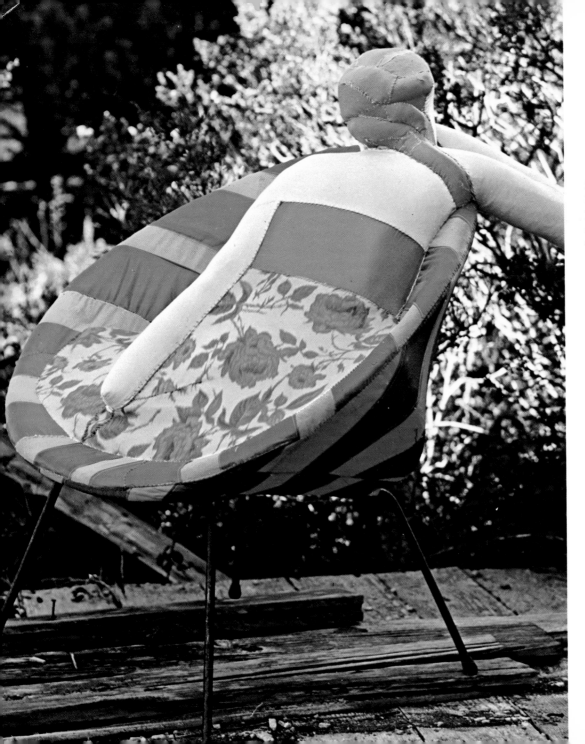

30.
Woman Looking Out to Sea.
1964. Stuffed cloth
on metal chair frame,
43 x 26 x 31″

31.
Woman Looking Out to Sea

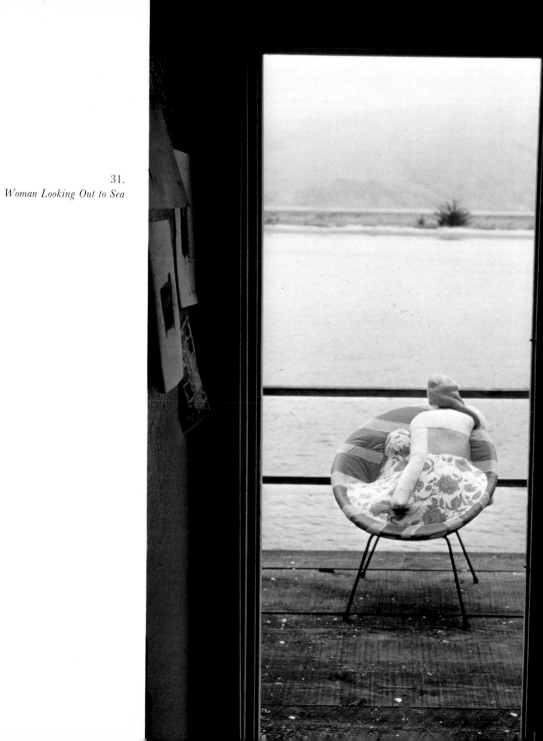

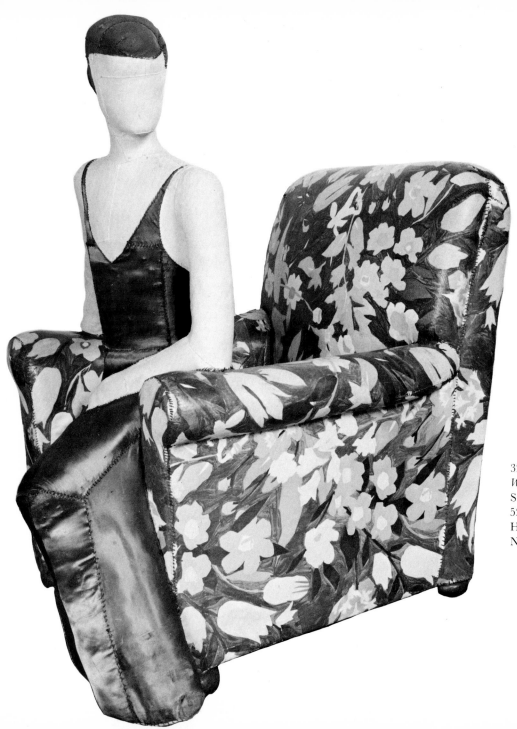

32.
Woman in Green Gown. 1964.
Stuffed cloth on wood chair frame,
52 x 36 x 36".
Harry N. Abrams Family Collection,
New York

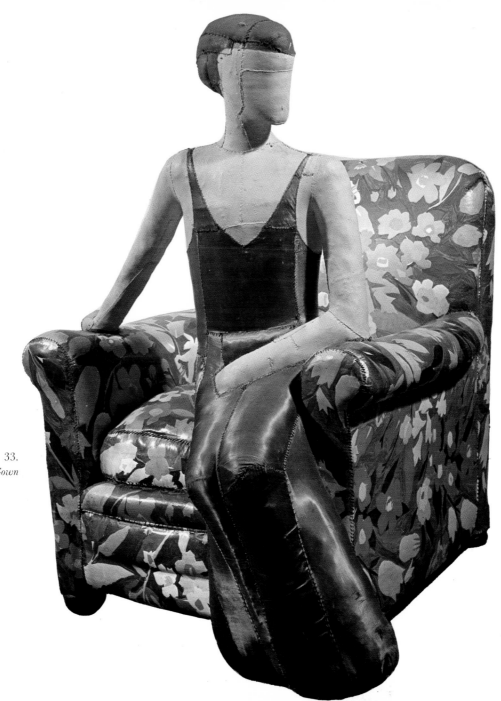

33.
Woman in Green Gown

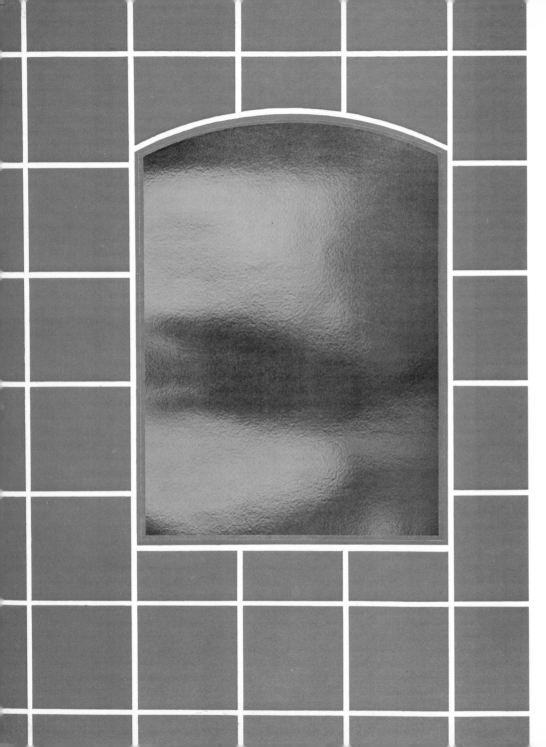

34.
Bathroom. 1969.
Lithograph with self-adhesive
Fasson foil, 30 x 22″

35.
Woman Giving Her Greeting. 1964.
Stuffed cloth on metal frame,
72 x 23 x 26"

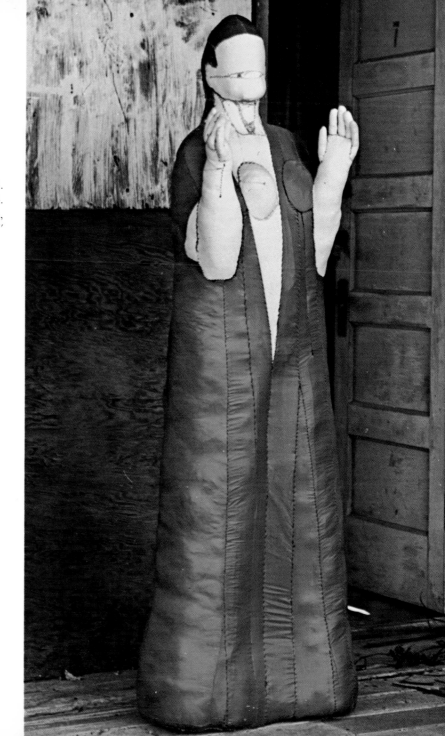

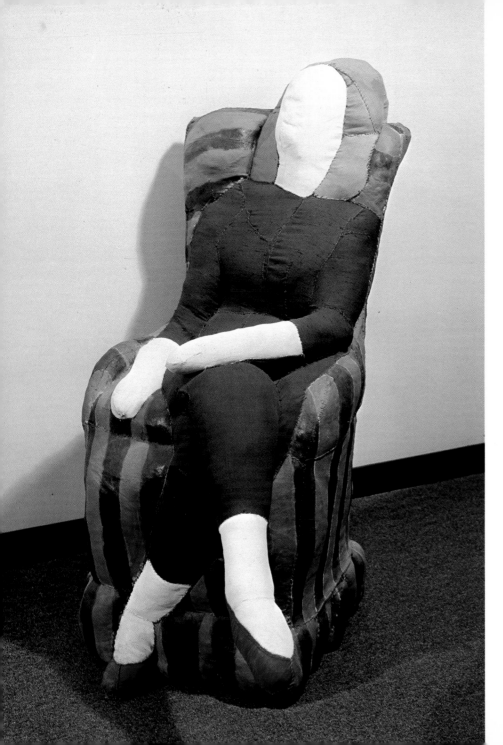

36.
Woman in Blue Slacks. 1963.
Stuffed cloth on wood chair frame,
50 x 32 x 30".
Harry N. Abrams Family Collection,
New York

37. *Dream on a Red Couch.* 1964. Stuffed cloth on wicker couch frame, 40 x 52 x 31″. Collection Audry Sabol, Villanova, Pa.

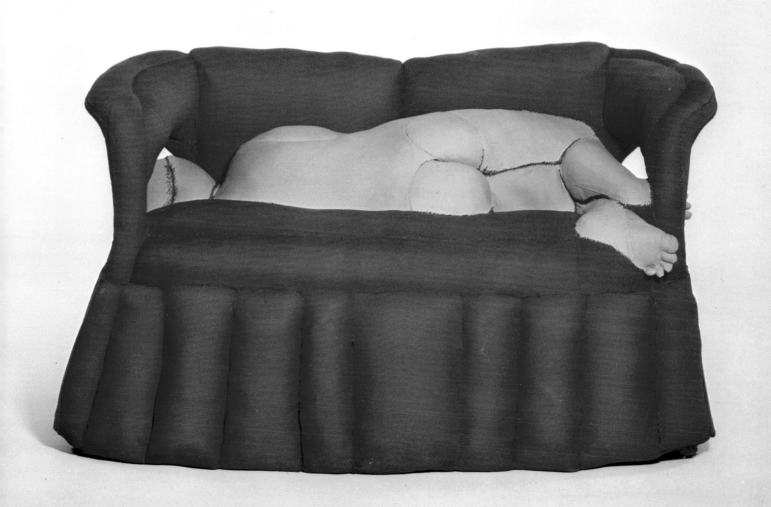

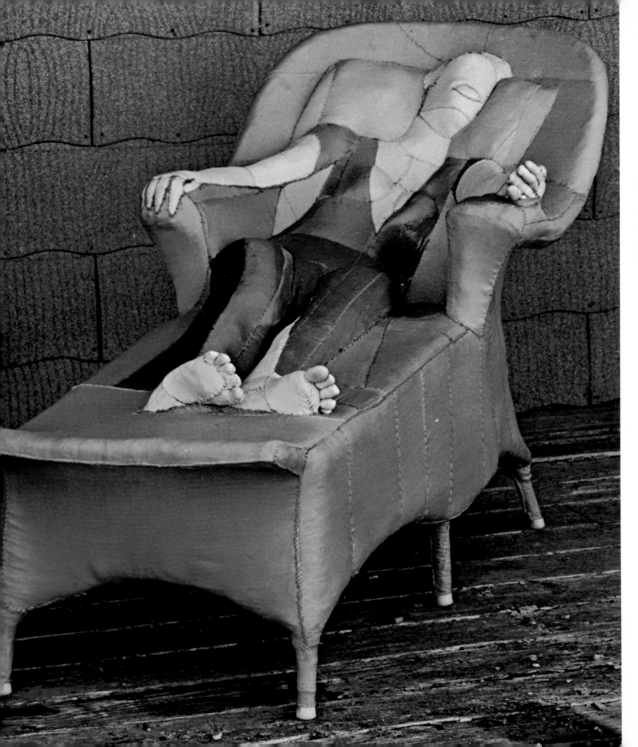

38.
The Convalescent. 1965.
Stuffed cloth on wicker
chaise-longue frame,
42 x 32 x 80″.
Private collection, Germany

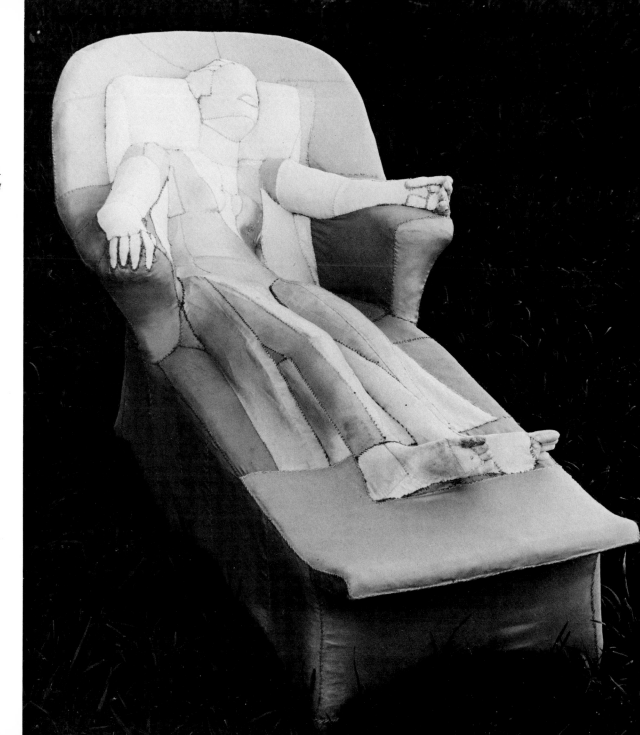

39.
The Convalescent

40.
At Night. 1969.
Lithograph, 30 x 22″

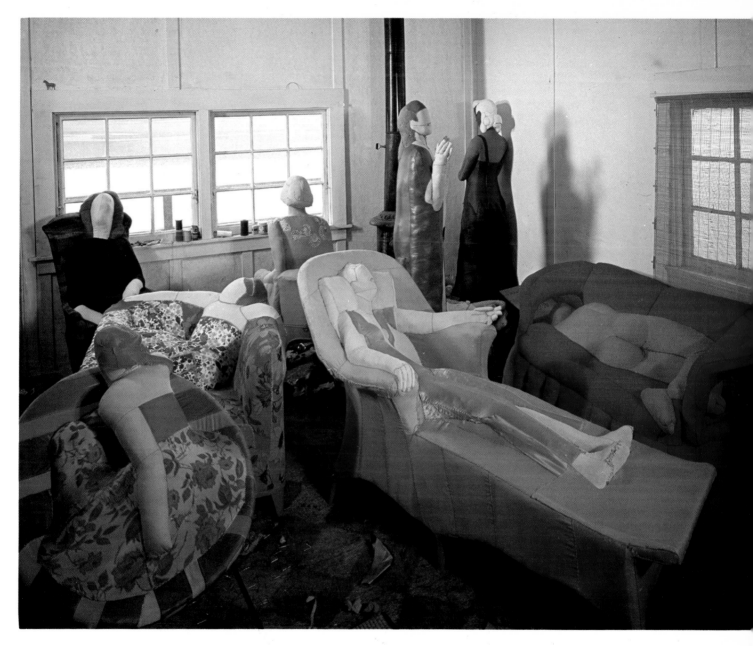

41. Eight Women in the Studio, Bolinas, 1965

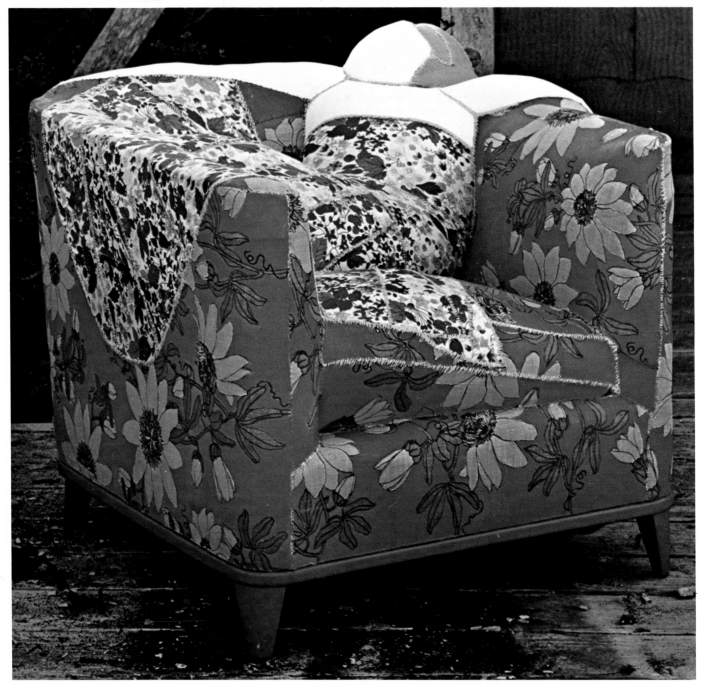

42. *Woman Laughing*. 1967. Stuffed cloth on wood frame, painted, 41 x 36 x 36". Los Angeles County Museum of Art

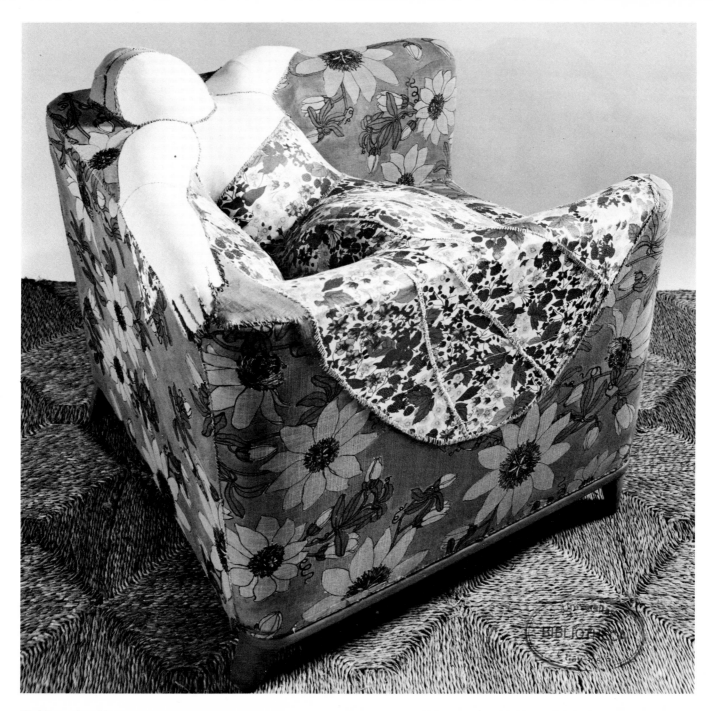

43. *Woman Laughing*

44.
Bouquet. 1968.
Bronze, 35 x 23"

45.
Outdoors. 1970.
Lithograph, 30 x 22″

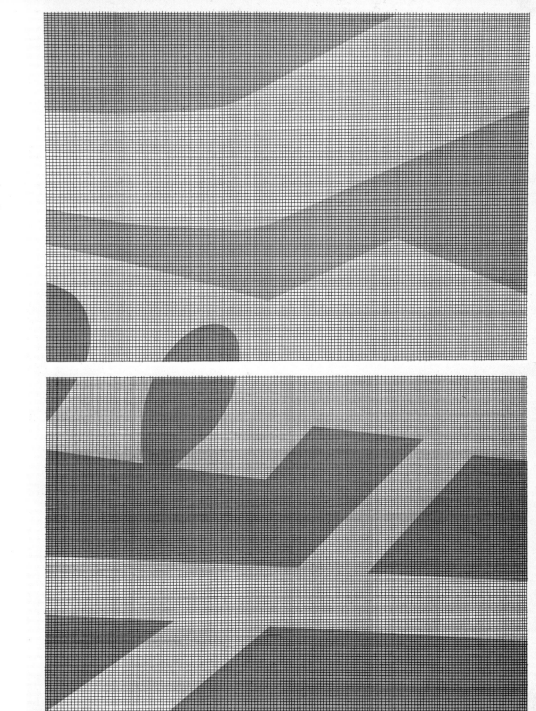

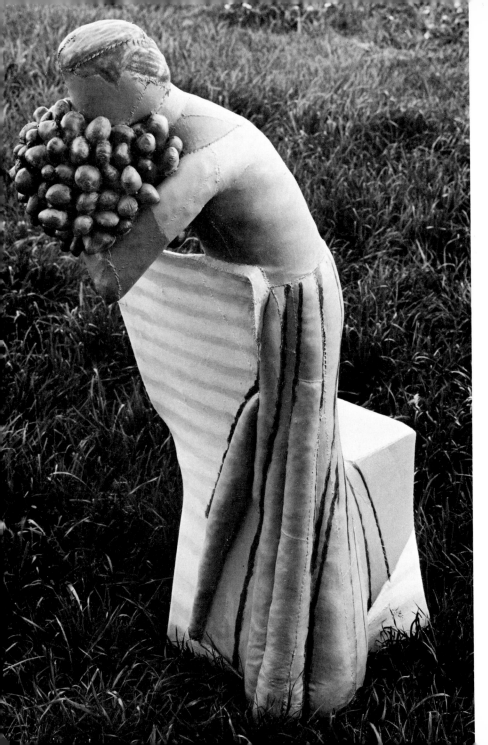

46.
Woman Smelling Her Roses (Version I).
1967. Painted cloth,
stuffed, on wood chair frame,
51 x 49″

47.
Woman Smelling Her Roses (Version II).
1968. Stuffed cloth, painted,
on wood chair frame,
51 x 49″.
Neue Galerie der Stadt Aachen

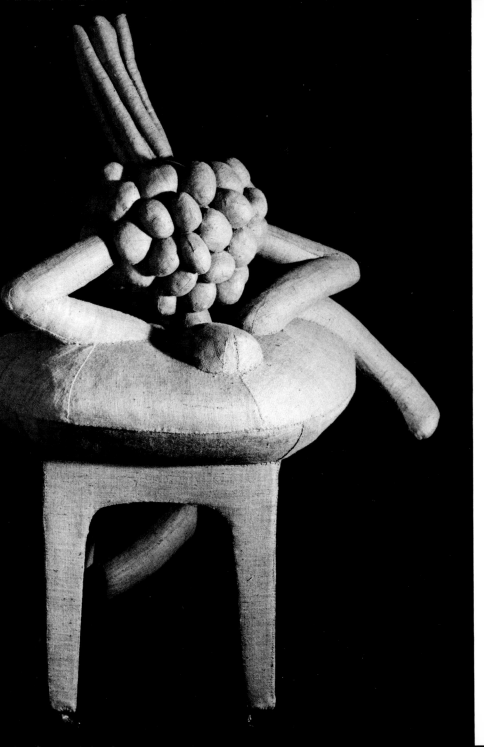

48.
Anna Smelling Her Blooms.
1968–72. Stuffed cloth
on wood frame,
71 x 56 x 50″

49.
Anna Smelling Her Blooms

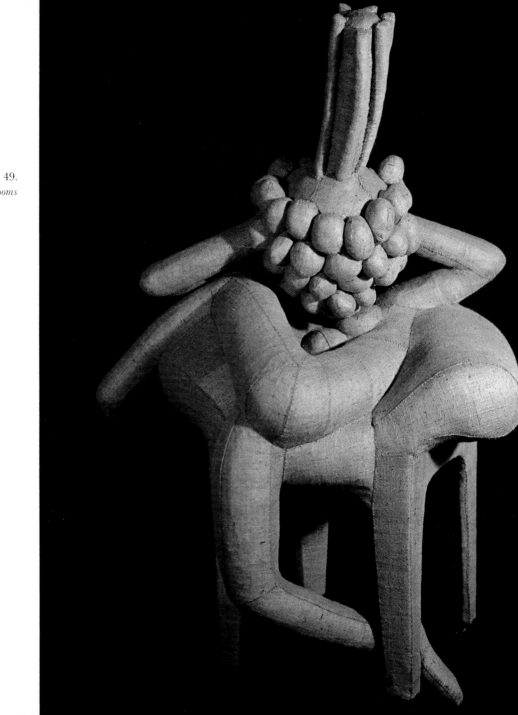

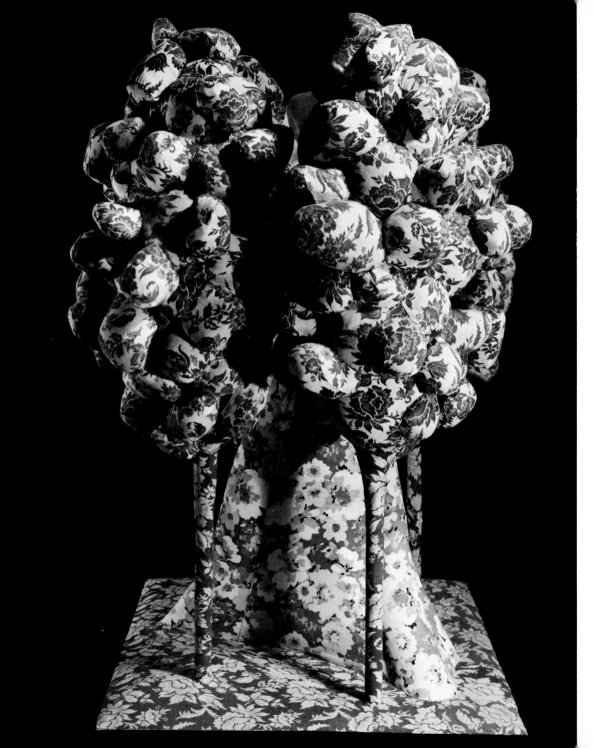

50.
Norissa Rushing. 1971–72.
Stuffed cloth on wood
and metal frame, 85 x 72 x 69″

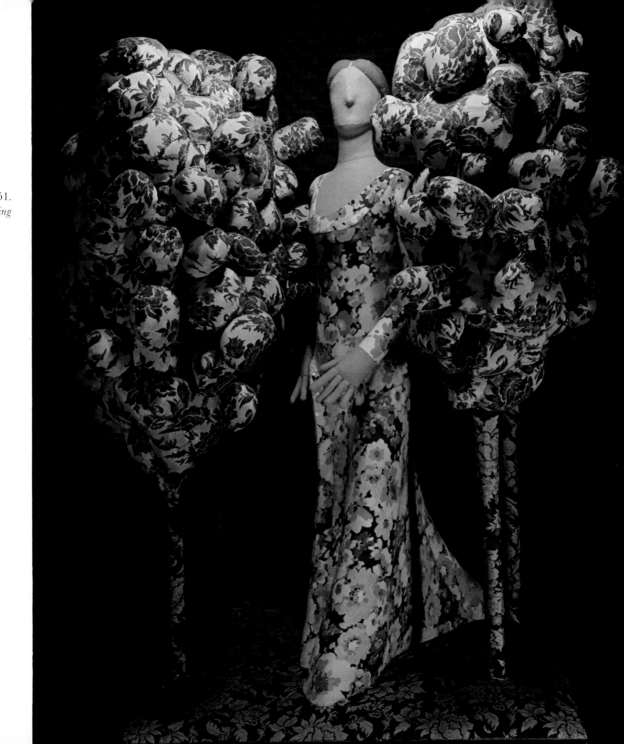

51.
Norissa Rushing

52. *El Cemetario Central.* 1970. Lithograph, 22 x 30″

53.
A Lamp and a Cup.
1966. Bronze,
26 x 22 x 9″

54. *Traveling Case.* 1970. Lithograph, 22 x 30″

55. *A Girl on the Beach.* 1969. Lithograph, 22 x 30″

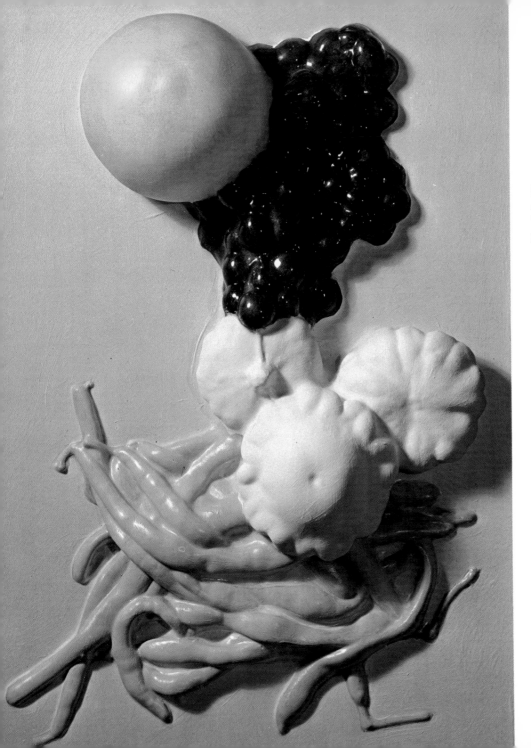

56.
Painted Grapefruit. 1967.
Vacuum-formed plexiglass,
painted, 11 x 14 x 5″

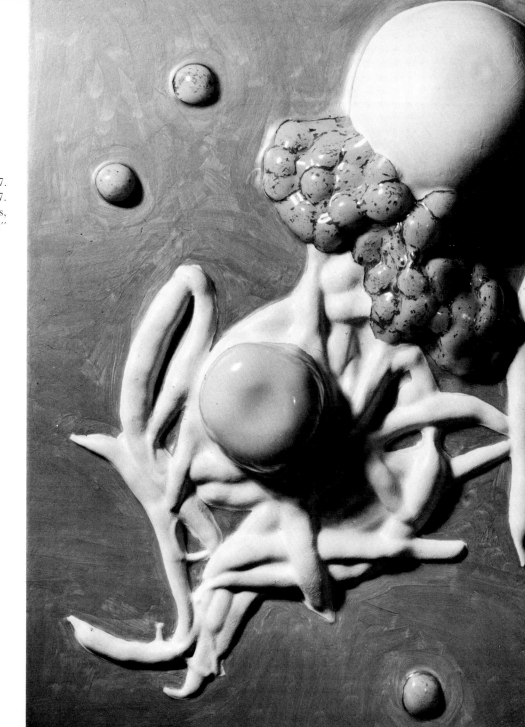

57.
Green Apple. 1967.
Vacuum-formed plexiglass,
painted, 11 x 14 x 5"

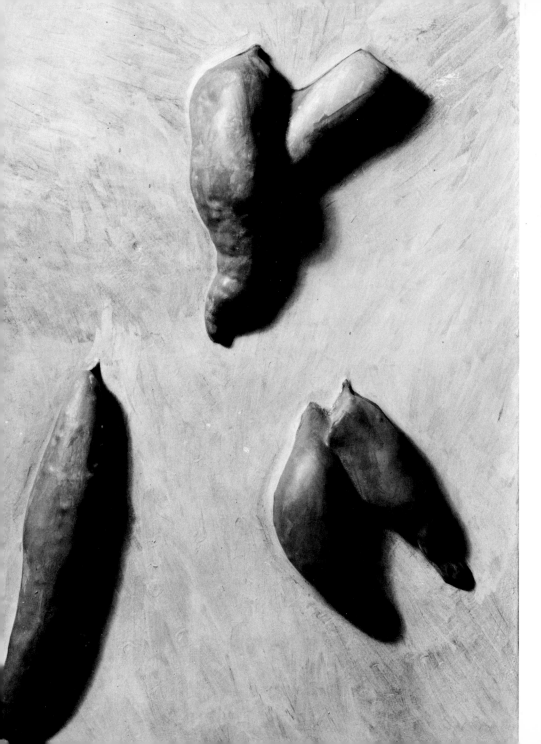

58.
Painted Yams. 1967.
Vacuum-formed plexiglass,
painted, 11 x 14 x 4"

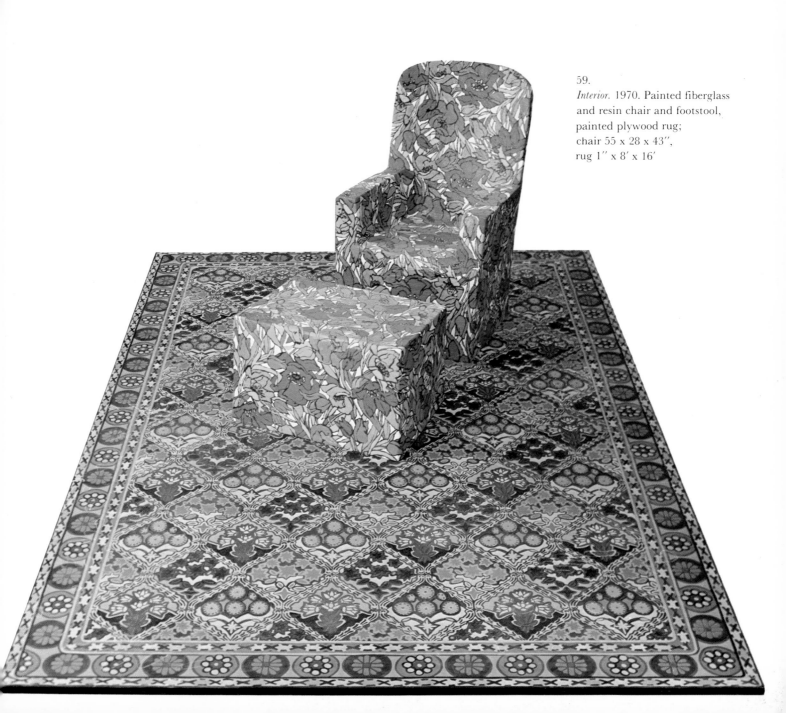

59.
Interior. 1970. Painted fiberglass
and resin chair and footstool,
painted plywood rug;
chair 55 x 28 x 43″,
rug 1″ x 8′ x 16′

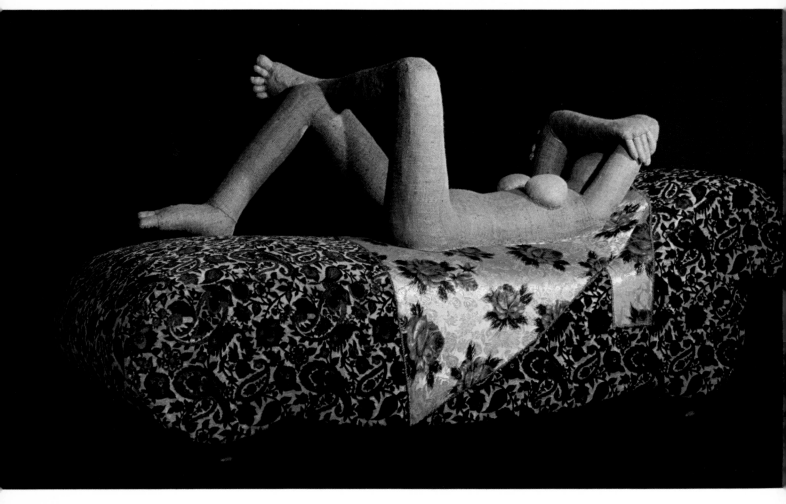

60. *Ruth Williams Resting.* 1972. Stuffed cloth on wood chaise-longue frame, 41 x 72 x 26″

61. *Ruth Williams Resting*

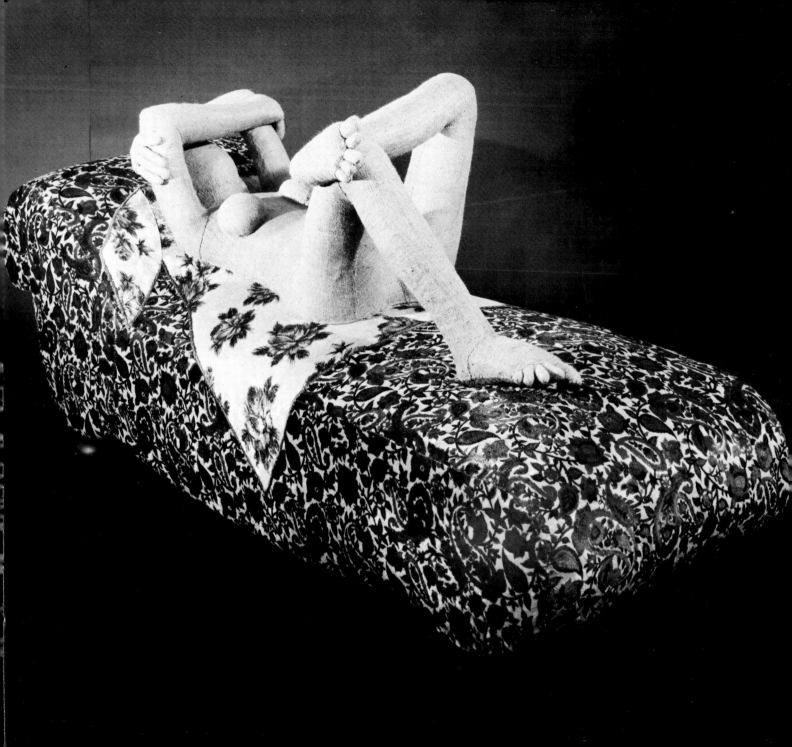

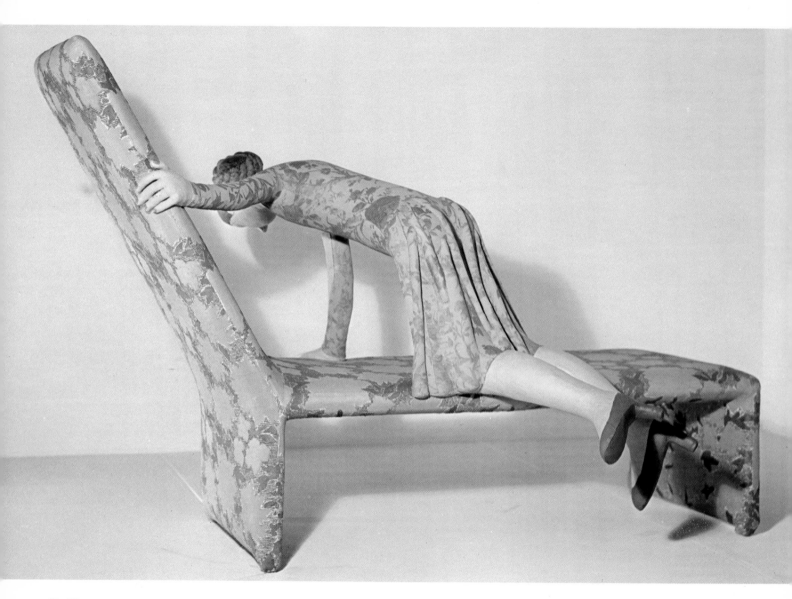

62. *Eleanor Looking For.* 1973. Stuffed cloth on aluminum frame, 50 x 49 x 78"

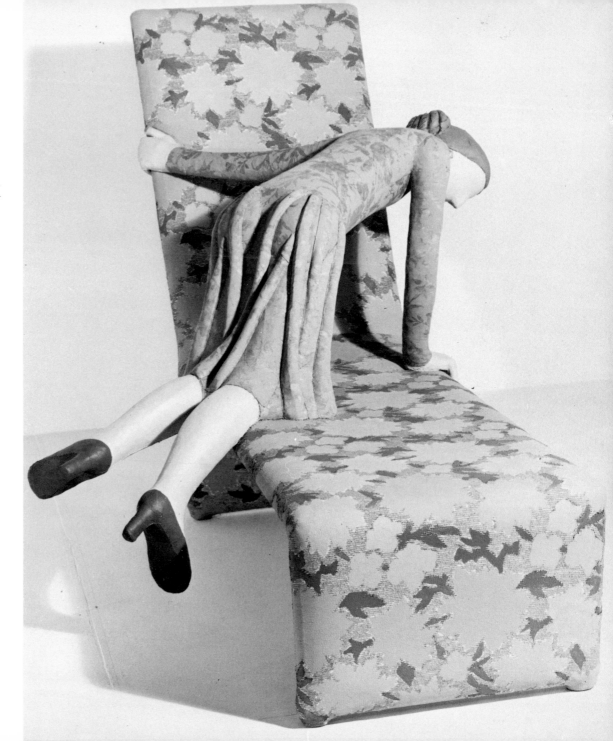

63.
Eleanor Looking For

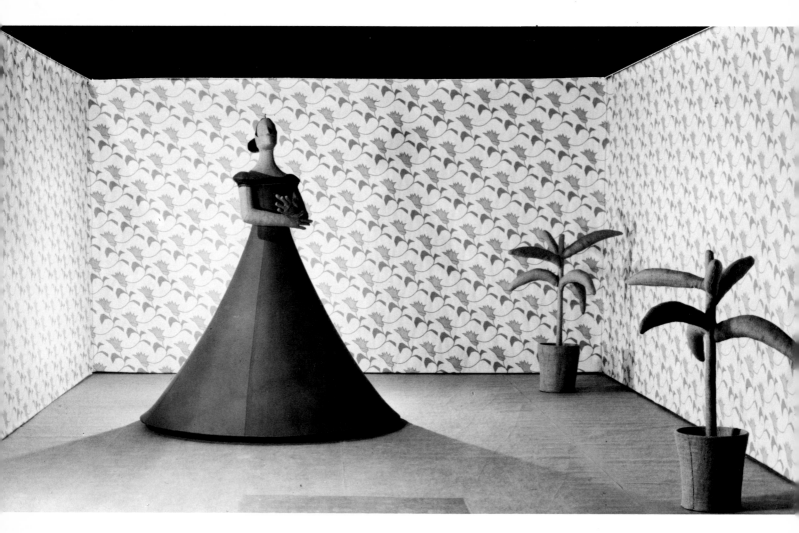

64. *Flo Waiting.* 1971–1972. Partially stuffed cloth figure with cloth skirt on metal hoops
hanging in room of painted canvas walls suspended from metal rods, 8'6'' x 16' x 24'

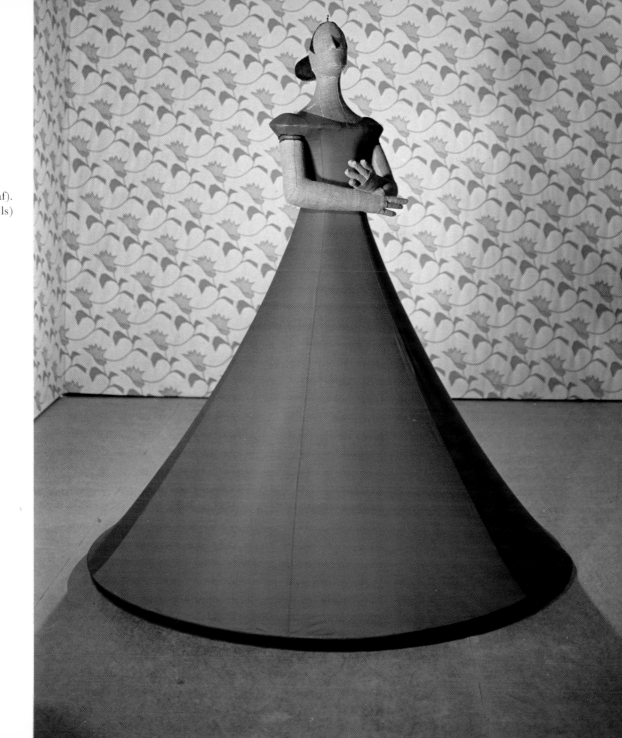

65, 66. (overleaf).
Flo Waiting (details)

Biography

1925 Born November 5 in Orlando, Florida.

1938–41 Studies drawing and painting with Joy Karen Winslow.

1943 Studies during the summer at the Chouinard School of Art, Los Angeles.

1944 Serves in the U.S. Navy aboard the destroyer *Ault.*

1945 Receives Fleet Appointment to the U.S. Naval Academy, Annapolis.

1946 Begins study at the University of New Mexico, Albuquerque.

1948–49 Studies drawing with Johannes Molzahn at the New School for Social Research, New York. Studies painting with Hans Hofmann at his summer school in Provincetown, Massachusetts.

1950 Marries Marguerite Kirk. Receives B.F.A. degree from the University of New Mexico.

1951 Son Christopher born in Albuquerque, New Mexico.

1953 Teaches at Knox College, Spaldings, Jamaica.

1954 Son Nicholas born in Papine, Jamaica.

1955–56 Editorial Associate, *Art News* magazine.

1960 Receives Longview Foundation Grant.

1961–62 Fulbright Professor at the Universidad Catolica de Chile, Santiago.

1962 Universidad Catolica de Chile confers Miembro Academico de la Facultad de las Bellas Artes.

1963 Moves to Bolinas, California.

1967 Receives Neallie Sullivan Award, San Francisco Institute of Art.

1969–70 Tamarind Lithography Workshop Fellow.

List of Exhibitions

San Francisco Museum of Art, "Eleventh Annual Selection for the Society for the Encouragement of Contemporary Art," 1966

Maryland Institute, College of Art, Baltimore, "61–66, The Work of Visiting Artists," 1966

Institute of Contemporary Art, University of Pennsylvania, Philadelphia, "New Art in Philadelphia," 1966

Museum of Contemporary Crafts, New York, "People Figures," 1966–67

Los Angeles County Museum of Art, "Sculpture of the Sixties," traveled to Philadelphia Museum of Art, 1967

IX Bienal de São Paulo, Brazil, "Environment U.S.A.: 1957–1967," organized by William C. Seitz for the National Collection of Fine Arts, Washington, D.C., 1967

Kunsthalle, Düsseldorf, Germany, "Prospect '68," 1968

University Galleries, University of Nevada, Reno, "Sculpture Invitational," 1968

Smithsonian Institution, Washington, D.C., "New American Figurative Art, 1963–1968," organized by Constance M. Perkins for European tour, 1968–69: Museum of Modern Art, Belgrade; Kölnischer Kunstverein, Cologne; Staatliche Kunsthalle, Baden-Baden; Musée d'Art et d'Histoire, Geneva; Palais des Beaux-Arts, Brussels; Museum des 20. Jahrhunderts, Vienna; Galleria d'Arte Moderna, Padiglione d'Arte Contemporanea, Milan

New Jersey State Museum, Trenton, "Soft Art," 1969

California College of Arts and Crafts Gallery, Oakland, "A Show of Hands," 1970

Recklinghausen, Germany, "Ruhrfestspiele," 1970

Basel, "Art 70," 1970

Kunsthalle, Cologne, "Kunstmarkt 70," 1970

M.H. de Young Memorial Museum, San Francisco, "San Francisco Art Institute Centennial Exhibition," 1971

Grunwald Graphic Arts Foundation Gallery, University of California at Los Angeles, "Made in California," 1971

International Exhibitions Foundation, Washington, D.C., "Tamarind, a Renaissance of Lithography," traveling exhibition, 1971–72

ACA Galleries, New York, "Looking West," 1972

Los Angeles County Museum of Art, "Anatomy in Fabric," 1973

Museum of Contemporary Crafts, New York, "Sewn, Stitched, and Stuffed," 1973

The Contemporary Arts Center of Cincinnati, "Sculpture in Cloth," 1973

The Gallery of the College of Marin, Kentfield, California, "Seven Bay Area Sculptors," 1974

Bibliography

BOOKS AND CATALOGUES

Sculpture U.S.A. The Museum of Modern Art, New York, 1959

Cantar de los Cantares de Salomon; trece grabados. Santiago de Chile: Teller 99, 1961. Hand-printed edition of 63, one copper engraving by artist.

Art '65. New York World's Fair, American Express Pavilion, 1965

How the West Has Done. Philadelphia: Arts Council of the Y.M.H.A., 1965, illus.

American Sculpture of the Sixties. Los Angeles: Los Angeles County Museum of Art, 1966, illus.

New Art in Philadelphia. Philadelphia: Institute of Contemporary Art, 1966, illus.

People Figures. New York: Museum of Contemporary Crafts, 1966–67

São Paulo 9, Environment U.S.A. 1957–1967. Washington: Smithsonian Institution Press, 1967, illus. Photo of artist, biographical sketch, and artist's story in English and Portuguese.

Kultermann, Udo. *The New Sculpture: Environments and Assemblages.* New York: Praeger, 1968

Prospect '68. Düsseldorf, Germany: Kunsthalle, 1968

University of Nevada—1968 Sculpture Invitational. Reno: University of Nevada, 1968, illus.

Dunning, Stephen, and others. *Some Haystacks Don't Even Have Any Needle.* Glenview, Ill.: Scott, Foresman & Co., 1969. Illustration of sculpture accompanying poem by Merril Moore.

Neue Figuration U.S.A. Cologne: Kölnischer Kunstverein, 1969, illus. Biography and story by artist (in German).

Neue Figuration U.S.A. Vienna: Museum des 20. Jahrhunderts, 1969, illus. Biography and story by artist (in German).

Novi pravac Figura 1963–1968. Belgrade: Belgrade Museum of Modern Art, 1969, illus. Biography and story by artist (in Czechoslovakian).

Pomeroy, Ralph. *Soft Art.* Trenton, New Jersey: New Jersey State Museum Cultural Center, 1969, illus.

Kelly, James J. *The Sculptural Idea.* Minneapolis: Burgess, 1970, illus.

Kunstmarkt 70. Cologne: Kunsthalle, 1970

Nuova figurazione U.S.A. Milan: Ripartizione Istituzione e Iniziative Culturali, 1970, illus. Biography and story by artist (in Italian).

Ruhrfestspiele. Recklinghausen, Germany, 1970

The Shut-In Suite. Los Angeles: Tamarind Lithography Workshop, 1970. 21 lithographs.

Bloch, E. Maurice. *Tamarind: A Renaissance of Lithography.* Washington, D.C.: International Exhibition Foundation, 1971, illus.

Becker, Wolfgang. *Kunst um 1970.* Aachen, Germany: Neue Galerie der Stadt Aachen, 1972, illus.

Foley, Suzanne. *Paul Harris.* San Francisco Museum of Art, 1972, illus.

Kahmen, Volker. *Erotic Art Today.* Boston: New York Graphic Society, 1972, illus.

Looking West. New York: ACA Galleries, 1972, illus.

Anatomy in Fabric. Los Angeles County Museum of Art, 1973, illus.

Sewn, Stitched, and Stuffed. New York: Museum of Contemporary Crafts, 1973, illus.

Harris, Paul, and Dorothy Schmidt. *Torso.* San Francisco: Wrongtree Press, 1974. Text by Dorothy Schmidt, lithographs by Paul Harris.

Lipman, Jean. *Provocative Parallels.* New York: E.P. Dutton

ARTICLES AND REVIEWS

"Exhibition at Poindexter Gallery," *Art News*, vol. 57, June 1958, p. 16, illus.

Dash, R. Warren. "Exhibition at Poindexter Gallery," *Arts*, vol. 32, June 1958, pp. 32, 55, illus.

Hess, Thomas B. "U.S. Sculpture: Some Recent Directions," *Portfolio, Including Art News Annual*, no. 1, 1959, p. 112, illus.

Preston, Stewart. "Full Speed in All Directions," *The New York Times*, September 25, 1960

Lenson, Michael. "Sculptor," *Newark, New Jersey, Sunday News*, October 2, 1960

"Paul Harris, Mark di Suvero," *Art News*, vol. 59, October 1960, p. 44, illus.

de Mott, Helen. "In the Galleries: Paul Harris," *Arts*, vol. 35, October 1960, p. 64

Porter, Fairfield. "Art," *The Nation*, vol. 191, no. 12, October 15, 1960, p. 256

"Clarinete Escultórico en Claustre Colonial," *Ercilla*, Santiago de Chile, December 1961, p. 2, illus.

"New Talent U.S.A.: Sculpture," *Art in America*, vol. 50, no. 1, 1962, pp. 36–37, illus.

Tillim, Sidney. "Exhibition at Poindexter Gallery," *Arts*, vol. 37, April 1963, p. 58, illus.

Sandler, Irving. "Exhibition at Poindexter Gallery," *Art News*, vol. 62, no. 2, April 1963, p. 14, illus.

Adams, Alice. "Exhibition at Poindexter Gallery," *Craft Horizons*, vol. 33, no. 8, May 1963, p. 44, illus.

Harris, Paul. "Sculptors in Chile," *Art in America*, vol. 50, no. 2, Summer 1963, pp. 122–123

Rose, Barbara. "Filthy Pictures," *Artforum*, vol. 3, no. 8, May 1965, p. 21, illus.

Melville, Robert. "Exhibition at Lanyon Gallery in Palo Alto," *Architectural Review*, vol. 138, July 1965, p. 57, illus.

"Artists: Assemblage at the Frontier," *Time*, vol. 86, October 15, 1965, pp. 106–107, illus.

Constable, Rosalind. "Is It Painting or Is It Sculpture?" *Life International*, December 20, 1965, pp. 131–134, illus.

Grafly, Dorothy. "Pop Sweeps Our Way From Beyond the Divide," *The Philadelphia Bulletin*, March 13, 1966, p. 3, illus.

Frankenstein, Alfred. "Toys and Toying with Art," *San Francisco Chronicle*, September 12, 1966, p. 53, illus.

Bloomfield, Arthur. "Three Art Shows Offer Some Lemons and Plums," *San Francisco Examiner*, September 13, 1966, p. 28, illus.

Gruen, John. "Review," *World Journal Tribune, N.Y.*, December 23, 1966

Perreault, John. "Sunshine Materialism," *The Village Voice*, January 5, 1967, p. 13

Campbell, Lawrence. "Exhibition at Poindexter Gallery," *Art News*, vol. 65, February 1967, p. 15, illus.

Pincus-Witten, Robert. "Exhibition at Poindexter Gallery," *Artforum*, vol. 5, no. 7, March 1967, pp. 50–52, illus.

"Sculpture: It Comes from all Directions," *Los Angeles Herald-Examiner, California Living*, April 23, 1967, p. 28

"The Third Dimension," *Newsweek*, vol. 69, May 8, 1967, pp. 92–94, illus.

Albright, Thomas. "Abundant, Ambitious Sculpture," *San Francisco Chronicle*, May 28, 1967, pp. 38–39

Gosling, Nigel. "Pure American Funk," *The Observer Review* (London), June 25, 1967

Leider, Philip. "American Sculpture at Los Angeles County Museum," *Artforum*, vol. V, no. 10, Summer 1967, pp. 6–10

Grafly, Dorothy. "For the 60's, Sculpture with Color

and Light," *The Philadelphia Bulletin,* September 17, 1967, p. 10, illus.

Sabol, Blair. "The Artist Views Fashion," *The Village Voice,* April 25, 1968, p. 22, illus.

"Exhibition at Poindexter," *Art News,* vol. 57, June 1968, p. 16

Johnson, Charles. "Descendant of Cézanne," *Sacramento Bee,* September 20, 1968, pp. 16–17

Pomeroy, Ralph. "Soft Objects at the New Jersey State Museum," *Arts,* vol. 43, March 1969, p. 47, illus.

Pomeroy, Ralph. "New York: Soft Art," *Art and Artists,* vol. 4, April 1969, p. 27, illus.

Kohler, Arnold. "Nouvelle figuration américaine," *Tribune de Genéve,* August 6, 1969

Bruggeman, Leo. "Terugkeer van het beeld in de amerikaanse kunst," *De Nieuwe Gids* (Brussels), October 25, 1969

"Art americain d'aujourd'hui," *Werk* (Winterthur), November 9, 1969, pp. 650–651, illus.

Sterk, Harald. "Altes und Neues, bunt gemischt," *Volksstimme* (Vienna), December 6, 1969

Mayer, Gerhard. "Zweierlei Lustgewinn," *Wochenpresse* (Vienna), December 10, 1969

Buzzati, Dino. "Neoerotismo americano," *Corriere della Sera* (Milan), January 29, 1970

Valsecchi, Marco. "Hanno fissato in calco le cronache dell'orrido," *Il Giorno* (Milan), February 3, 1970, illus.

"L'Arte figurativa americana dal 1945 ad oggi," *La Prealpina* (Varese), February 11, 1970

Salvi, Elvira Cassa. "Il ritorno della figura umana nell'arte della giovane America," *Giornale di Brescia,* February 15, 1970, illus.

Ghiberti, Stefano. "Hanno Esposto Anche I Pantaloni," *Gente* (Milan), February 16, 1970

Cavazzini, Gianni. "Lo spirito di ricerca degli artisti americani," *Gazetta di Parma,* February 1970

Frackman, Noel. "Paul Harris at Poindexter," *Arts,* vol. 44, May 1970, p. 63

Kunstwerk, vol. 23, June 1970, p. 50, illus.

Bishop, James. "Exhibition at Poindexter Gallery," *Art News,* vol. 69, Summer 1970, p. 22

"L'Art americain a Genéve: richesse creatrice et eclatement des tendances," *Feuille d'Avis de Lausanne,* July 25, 1970

Le Arti (Milan), January–February 1970, cover illus.

Stiles, Knute. "San Francisco," *Artforum,* vol. 9, May 1971, p. 93, illus.

"Jam-Packed Museum Show," *San Francisco Chronicle,* May 8, 1972, illus.

Frankenstein, Alfred. "Superb Art on Grand Scale," *San Francisco Chronicle,* May 11, 1972, illus.

"Bay Area Point of View," *Artweek,* June 3, 1972, illus.

Polley, E.M. "Art and Artists: Bay Area Art on Grand Scale at San Francisco Museum," *Times-Herald* (Vallejo), June 4, 1972, illus.

"Art in the Local Museums," *San Francisco Examiner & Chronicle,* June 4, 1972, illus.

Johnson, Charles. "The Lively Arts," *Sacramento Bee,* June 11, 1972, pp. 3–4, illus.

Tarshin, Jerome. "Paul Harris," *Artforum,* vol. XI, no. 2, October 1972, illus.

Ames, Richard. "Chic Nihilism in UCSB Exhibits," *News-Press* (Santa Barbara), November 12, 1972, p. C-10, illus.

Photography Credits

The numbers refer to plate numbers.

John R. Bagley (San Francisco): 53; Rudolph A. Bender (San Francisco): 29, 39, 43, 46; Geoffrey Clements (New York): 34, 40, 45, 52, 54, 55; Robert Forth: 31, 36; Jack Fulton: 30, 35, 38, 42; Roger Gass: 10, 13, 14, 16–18, 21, 22, 24, 27, 48, 49, 50–52, 56–59, 62, 63, 65; Christopher Harris: 25, 26; Marguerite Harris: 5; Nicholas Harris: 2, 4, 6; Sergio Larrain: 19, 20, 23; Charles P. Mills: 37; Poindexter Gallery (New York): 7; Eric Pollitzer (New York): 32, 33; Leonard Sussman: 9, 11, 28, 44; Ian Sutherland: 12; Edwin Todd: 3, 8; Wilda Whitehall: 1